A Letter to My Mom

A Letter to My Mom

Also by Lisa Erspamer

A Letter to My Cat: Notes to Our Best Friends

A Letter to My Dog: Notes to Our Best Friends

A Letter to My Mom

LISA ERSPAMER

CROWN ARCHETYPE
New York

Published in the United States by Crown Archetype, an imprint of the Crown Publishing Group, a division of Random House LLC, a Penguin Random House Company, New York. www.crownpublishing.com

Crown Archetype and colophon is a registered trademark of Random House LLC.

Library of Congress Cataloging-in-Publication Data

A letter to my mom / [compiled by] Lisa Erspamer.—First Edition.
1. Mother and child—Pictorial works. 2. Mothers—Correspondance. 3. Mothers—Anecdotes. 4. Mothers—Pictorial works. I. Erspamer, Lisa.
HQ759.L4736 2014
306.874'3—dc23 2014030807

ISBN 978-0-8041-3967-0
eBook ISBN 978-0-8041-3968-7

Printed in China

Jacket design by Elena Giavaldi
Front jacket photograph (envelope): Creative Crop/Getty Images
A list of additional photograph credits appears on page 159.

10 9 8 7 6 5 4 3 2 1

First Edition

INTRODUCTION

......................................

A Letter to My Mom is the third book in our letter series to date. It has been a huge honor for us to curate letters from people all over the country and from around the world for this very special book. My team and I literally spent hours and hours at my kitchen table crying our eyes out as we read your letters out loud to each other trying to decide which to put in this collection. Every letter that was submitted touched us in ways we never expected. They were funny, heartwarming, heartbreaking, and just wonderful.

What started out as a simple idea turned into a catharsis for us all. We are grateful that you trusted us with your precious stories about your beautiful mothers and that you allowed us into your lives in such unique and vulnerable ways. For those of you whom I knew before you wrote these letters, I feel like a new layer of you has unfolded with these words. I am touched that you opened your-selves up to share a new piece of yourselves with me . . . and with all of the people who will read this book. Thank you for being so brave.

Now it's my turn.

To my mom.

Mom, as I have been curating this book, I have thought a lot about you, our relationship, and all of the things I have probably never said to you . . . like, thank you.

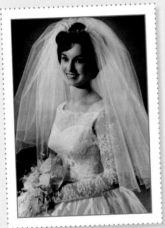

Thank you, Mom, for bringing me into this world.

Thank you for always supporting my dreams. I really think you believe I can do anything, even when I doubt myself.

Thank you for always thinking I was great no matter what I did or didn't do. You always think your kids can do no wrong, even when we're wrong . . . still to this day. Good for you!

Thank you for baking me many pink birthday cakes with pink swirled frosting. I remember those cakes; they were so beautiful.

Thank you for brushing my hair until I fell asleep when I was little and for making the scary monsters go away in the night.

Thank you for killing the spiders that the men in the house were too afraid to kill.

Thank you, I think, for waking me up most mornings with an annoying song and a squirt bottle full of water.

Thank you for standing up to mean Ms. X, my bullying teacher, by throwing the plant she gave you in the trash, right in front of her. You showed her, Mom!

Even if I never call, thank you for being willing to answer the phone anytime day or night. Thank you for wishing I would call.

Thank you for wanting to spend time with me, even when I didn't want to spend time with you. Thank you for giving me the space, but not giving up on me.

Thank you for taking care of Dad when he was dying and for not being mad at me when I wasn't there. Thank you for understanding why.

Thank you for moving on as best you could after he was gone. Thank you for trying to enjoy your life without him.

Thank you for putting up the tree, the stockings, and decorating the entire house at Christmas all by yourself, every year, and making it perfect for all of us.

Thank you for being such an amazing grandmother to your grandchildren. You are so special to each one of them. They are lucky to have so much of you in their lives.

Thank you for everything that you do for all of us. It's enough. It's perfect.

You're perfect.

I'm proud to have you as my mom.

I love you.

Lisa

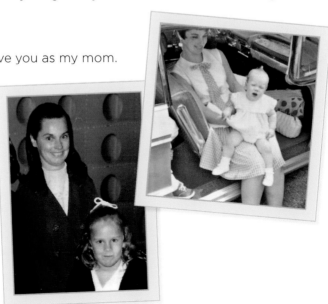

THE LETTERS

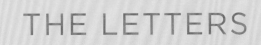

Dear Mom,

I have you to thank for the wonderful life that I have. Despite the fact that you had to adjust the future you envisioned for me given my unknown diagnosis of skeletal dysplasia, you never gave up on your wish that I could have a wonderful life.

Despite how young you were when I was born, all the challenges, and the unknown you faced, you were never frazzled or dismayed. As an infant, doctors told you horror stories—that I might not live, that if I did I would be physically and mentally disabled. At one point you were accused of not feeding me as the cause of my short stature. Despite all

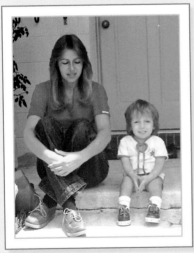

this, you never gave up on me. When you finally found a doctor who knew what was going on, you began your mission to give me the best chance at a healthy, happy, and productive life. You made sure that I got the best medical care even though it meant traveling 2,000 miles for every surgery and checkup. We often did these trips alone, almost every summer of my life. The fact that you fainted every time you saw me in the recovery room after every surgery and my surgeon kept smelling salts in his pocket was evidence that it destroyed you to see me in pain. Despite fear and anguish, you tackled these medical challenges head-on with the goal of giving me a wonderful life.

Mom, you not only made sure I had the best chance physically to achieve in life, but you imparted to me the attitude as well.

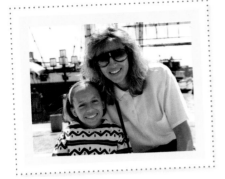
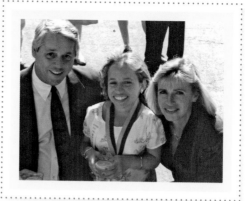

If I ever said I couldn't do something due to my stature, you would ask, "How do you know until you try?" Although you never doubted me and reminded me that I could achieve anything I wanted with hard work and perseverance, you also reminded me of how much I have to be thankful for and to never take things for granted. You weren't afraid to tell me that I couldn't do a job of physical labor when I grew up, like you did. However, there was no excuse for not finding a career that could provide success by using my brain. Working hard and doing well in school was not optional in our house. Thank you, Mom, for not treating me differently—it has made me tough, independent, and ultimately happy. I have seen other parents in similar shoes not have high expectations of their children due to their disability. I am thankful you expected of me as you would any child. Although you may not have asked me to mow the lawn or wash the car, I still had plenty of other chores to do. It wasn't just your devotion to

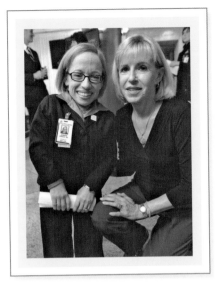

my health and education, but also your attention to the little things, that shaped me into a self-confident, happy, and healthy person today.

For example, no matter how hard it was to find clothes that fit and were appropriate for my age, you never settled for clothes with teddy bears and ducks. I have fond memories of spending hours together at the mall hunting for "not babyish" clothing in my size. We still bond today with our shopping missions! Just because I was a Little Person did not mean I couldn't look like everyone else my age.

Somehow, Mom, you made sure I had the physical ability, the self-confidence, the education, and the style to achieve anything I wanted in life. I don't know how you did all that you did and often wonder if you realize how much you have shaped me. You taught me that feeling sorry for myself was not only a waste of time, but selfish. Ultimately, no matter my size or physical challenges, I deserved and was capable of creating a happy and good life!

Now that I am a new mother, I find myself instilling the same life lessons in Will and Zoey that you taught me—humility, hard work, independence, and most important, happiness. I hope that I can inspire them to make a wonderful life for themselves as you have inspired me!

I love you, Mom!
Jennifer

Dear Mom,

Now that I have a child of my own and have chosen to dedicate my time to raising her, I cringe at something I said to you in my teenage years. I remember coming home after school, and you were sitting at the kitchen table waiting to ask about my day. I was in my junior year, I think, and though I was a pretty good kid, I was yearning to get into a little trouble. I don't remember what set me off that day in particular. Maybe you were just being your sweet self, offering to make me a snack, or maybe you told me I couldn't do something I wanted to do or go somewhere I wanted to go. Whatever it was, I snapped, "Why can't you just get a job? Why do you have to be home all the time? Isn't there anything else you want to be doing with your life?"

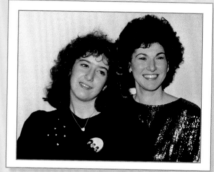

As soon as I said it, I regretted it. I saw your face in response to my harsh words and wished I could take it back. But I couldn't. I didn't even try. I just stormed off in typical teenage fashion, leaving you to feel attacked and unappreciated. I can only imagine, now that I have an almost three-year-old daughter, how devastated I would feel hearing those words. How after all I have sacrificed in just these few years, I would feel so betrayed, so dismissed.

So let me tell you now, in case I've never cleared it up for you: that wasn't the truth. If I could talk to my 17-year-old self, I'd tell her to have some respect. That instead of being a brat, I should tell you the truth. A truth maybe I was only able to see through years of being raised by you, leaving the house to live as an adult, and beginning the journey of raising a daughter of my own.

The truth is I wish I wouldn't have asked, "Why can't you get a job?" as if there's something you lacked by dedicating your life

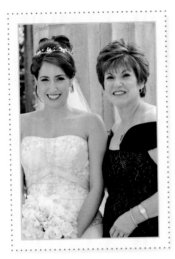

to raising me and Lainey. Instead I should've said "thank you." Thank you for making us the priority in your life. Thank you for being there to drop off our lunches at school if we forgot them or driving us to school if we missed the bus. Thank you for attending each recital, school play, choir concert, multiple times, every time. Thank you for baking our birthday cakes even though cooking wasn't your thing. Thank you for praising our good grades but never asking why a "B" wasn't an "A." Thank you for having rules to keep us in line and for sticking to your values even when we told you you were wrong and uncool and everyone else's parents were letting their kids do this or that.

I thought you didn't get it, but now I finally do. Thank you for loving me enough to set those boundaries, but being wise enough to give me room to explore and be young and have fun. Thank you for always being so available to me through the years and especially for our late-night phone calls. It still cracks me up when I call you close to midnight, only to hear you say, "I'm just on the other line with Aunt Myrna, hold on a sec, let me tell her I'll call her back." Thank you for saying you're proud of me, for cheering me on. Thank you for continuing to chant "Rudy, Rudy, Rudy" to remind me of my favorite movie and inspire me when I'm down. Thank you for always "showing up" through the good, the bad, and the ugly. Even when we disagree, I know I can count on you, and that brings me more comfort than I can express.

Thank you for coming to stay with me for almost two months after Jessica was born to teach me how to mother, to help me by holding her and changing her and washing bottles and doing laundry. And for coming back a few days after you finally made it home, when I sprained my ankle and needed help again. Thank you for teaching me the importance of taking pride in being a mom as a job, a purpose, a calling.

I guess what I'm trying to say is thank you for always being there. Even when I didn't appreciate it. I do now.

Love,
Felice

MICHELE TRACY BERGER

Patricia Brooks

Dear Mom,

I want to thank you for your bravery on that late fall day in 1977.
When I was nine, you walked into my room and said, "We're leaving your stepfather. You have ten minutes to take anything you can carry and want to bring along." Without hesitation, I grabbed my favorite toy, the Bionic Woman doll, and my newly acquired glasses.

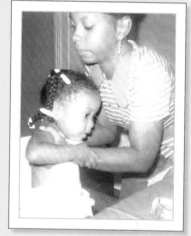

You dressed Melissa, my squalling two-year-old sister, and shortly after we said a teary good-bye to our cat Tinkerbell, and to the Brooklyn apartment that had been our home, and walked out into the wintry evening with just the clothes on our backs.

Although surprised by your decision, I knew the seed of change had been planted a few days before that, when I told you, out of the blue, that my stepfather, "Oscar Daddy," came into my room every morning and touched me. Once I started the telling, I could not stop and told you that his visits had been going on for a long time. Although I did not know the phrase "escalating behavior" at that time, something in me knew that my best attempts at waking myself up and being dressed before he came into the room were not a sustainable or good long-term strategy.

Oscar was physically and emotionally abusive. You had tried unsuccessfully to leave him after he had kicked you in the stomach when you were pregnant with Melissa. I don't know how you got the best of your fear that day to leave him. But you did it.

After a short stint with your godparents, we found ourselves a few weeks before Christmas on a late afternoon waiting in the

15

Brooklyn Department of Social Services, homeless. I can't imagine the fear you had about what was to become of us. "What brings you here today, Ms. Brooks?" a caseworker asked.

"I've been a battered woman off and on for several years and finally decided we couldn't stay with this man." I could hear you trying out the truth to this stranger.

"We're ready to stay in a shelter." In the 1970s, shelters for "battered women" were new and an unknown phenomenon.

"Oh, no, Ms. Brooks. There's not a shelter that's empty that will take you with kids."

You stiffened. "I will not have my kids in foster care."

"But I think we can help," the caseworker said, raising a hand. "There's a new experimental program in Manhattan. At a hotel."

My ears perked up. A hotel? With silky sheets and a doorman? Where fancy people on television shows stayed? Cool!

"They have devoted an entire floor to housing battered women and their children. It's a six-month program. You could stay there until you get on your feet. You're lucky. There is one spot left. Wanna try it?"

You looked at me, nodded, and said, "Yes, we'll try it."

Bravery again!

Everything sped up. Our caseworker got us subway tokens, emergency food stamps, a small emergency check that could be cashed the next day, and paperwork to take to the hotel.

We arrived at the slightly run-down President Hotel, beyond tired.

One of the managers showed us to the room. I was excited by the big bathroom, the two queen-sized beds, and large television.

"There's no fridge, not even a hot plate. How are we supposed

to cook?" you asked no one in particular. I shrugged and you shrugged. You decided to worry about this issue later.

We all wanted to bathe, but we were so tired. We slipped out of our clothes and even though there were two beds, we cuddled like puppies into one. Our first night, I tucked my Bionic Woman doll in next to us. We were all home and safe.

I sometimes imagine what life would have been like if you hadn't left and I had grown up in that house. I weep for that shattered girl. I believe I would have run away and/or turned to drugs to numb the pain.

You gave me a life free from violence and soul-immobilizing fear. Watching you create a new life from almost nothing except your wits, taught me about the power of creativity and risk-taking. I bring that wisdom to all I do.

> *Watching you create a new life from almost nothing except your wits, taught me about the power of creativity and risk-taking.*

I am grateful to the unknown policy-makers, women's advocates, and others who came up with the innovative plan.

But I am most grateful to you for believing me and saving my life.

You never went back to him again. Brave.

Love,
Michele

Dear Mom,

 Whenever I look at myself I see physical features that remind me of your emotional and mental strengths. I remember that you are a single Korean mother who sacrificed your dreams to raise your children, and whose fierce independence makes you a survivor.

 My almond-shaped eyes never got to see the faces of your mother and father because they passed away when you were a child. They never saw the horrors of the Korean War, or the moment you first met my American G.I. father during the Vietnam War. They never saw the first time you stepped onto American soil, or the faces of people throughout your life who have embraced and shunned you for your Korean heritage.

 In your presence, my eyes see the strongest of female role models.

 My ears never heard the comments people made behind your back while you were living in Oklahoma. They never understood the sad phone conversations you had with your sister in Korea, or the happy conversations you shared with your friends as you reminisced about home. They didn't hear the arguments you had with my father because of his alcoholism, or the final conversation you had to confirm the divorce.

 They hear the sweetest sound when you say "I love you" because you rarely show affection.

 My mouth, which has the same thin upper lip and curious smile, has never spoken fluent Korean like yours, and it doesn't say a

genuine hello to every customer who comes through the dry cleaners' door. It loves kimchi just as much as yours, but it steers clear of the fish head soup that you occasionally enjoy on the weekends. Unlike yours, it can only handle so much spice.

My mouth sings perfectly in tune with yours when we listen to Patsy Cline's "Crazy."

My back, which rests comfortably against an office chair every day, has never felt over 60 years of hard labor like yours. It didn't have to stand tall as customers walked through a flea market store, or bend over machines in factories. It hasn't endured years of carrying laundry baskets or helping children move boxes to and from college.

It does, however, have a Korean tiger tattoo on it that represents strength, and it represents you.

My hands, which are exact replicas of yours, have long, frail fingers that also grip steering wheels cautiously. They don't handle chopsticks on an expert level like yours, but they mimic yours as they meticulously comb through thrift store racks to find the perfect deal.

You taught me the value of hard work, the importance of forgiveness, and the power of independence.

These hands grip you close every time we hug and say "good-bye."

Whenever I wear flip-flops or look down in the shower, I see your long toes and small feet. But my feet have never traveled long distances as a military wife. They didn't have to drive my father to an AA meeting, or to multiple jobs to pay the bills. However, they are feet that stood next to yours on the Honolulu shore when I got married, and for that I am grateful.

My feet would follow yours to the end of the earth without hesitation.

Mom, every day I am reminded of you. I look at myself and see the physical traits you passed on to me, as well as the unseen traits of compassion and integrity. You taught me the value of hard work, the importance of forgiveness, and the power of independence. You make me proud to be Korean, proud to be a woman, and, most importantly, proud to be your daughter.

Thank you,
Trish

Dear Mom:

I remember the first letters you sent to me. I was only seven and at sleepaway camp. Even though Dad was out of town, Anne was in the hospital for an emergency appendectomy, and Janet and the twins had summer activities you had to coordinate, you never failed to stay in touch with me.

When I left for college, you said I couldn't come home until Thanksgiving, wanting me to gain self-confidence. Instead, our letters flew back and forth, with a rhythmic regularity. I shared my fears and aspirations, lamenting the lonely Saturday nights, embracing three-hour-long chemistry lab sessions, traipsing across campus for late-night synchronized swimming. You listened, you responded, you were constant.

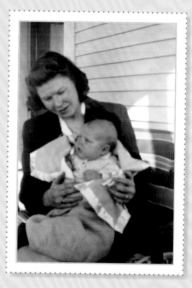

You saved my letters, my diary, really, from my year in England. I still read them occasionally, my tiny penmanship completely filling the fragile blue airmail paper. I again poured out my heart, in between asking you to research graduate schools, to send me care packages of instant hot chocolate and soft toilet paper, and to inquire into family and friends. You became the notes to myself.

You came to my rescue when I was a single mother, so frightened, with a newborn baby to protect. You made the decision when your parents' physical health declined, but pride prevented them from seeking help, to bring them into

21

your home. This was when you and Dad finally had time alone, together, without one or another of us children at home. You didn't complain, though; you just did it. You thought of others first, just like so many times during our lives.

In March 2006, you became the sole addressee of my letters. I admire your grace in learning to be a widow and our sole parent. You are now on the far side of ninety-one years. I ache for you, appreciating how much you dislike losing control, over your health, your daily activities, your body. I do not know how many more letters we will share. There will be an enormous hole in my weeks,

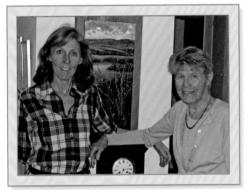

no longer on the lookout for your wriggly handwriting on tiny envelopes, the crossed-out words as your typing skills wane, and the inevitable newspaper clippings.

When you're gone, I will imagine composing letters to you in my mind, conveying news of my sons, describing the blooming flowers on our hillside, inquiring about the latest piano concert you've attended. And oh, by the way, when shall I come for a visit?

You constantly challenge me, embarrass me, and make me proud. I love you.

I fear the loss of the art of letter writing, a trail of history and love, our lives, really. I vow to continue this tradition with my children; maybe they'll learn more about me as I did about you through our decades of correspondence.

Your daughter,
Patricia (aka Patty)

Dear Mom,

You fiendish little minx. You didn't think I'd figure it out, did you?

I always knew you as a source of comfort and love. However, it's only now, as a parent in my own right, with the whole conspiracy laid out before me, that I can finally see the "Big Picture." Now I finally have some small idea of what it meant for you to be my mom.

Because, as a child, I only saw you through one set of eyes. You were lovely, warm, funny. You were occasionally overbearing and hapless. You embarrassed the hell out of me and yet you also had my complete loyalty and devotion (and you still do). I thought you were just a normal mom, like on TV.

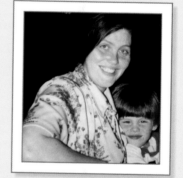

What I didn't realize was that being my mom meant you had to be one part Carol Brady and one part Keyser Söze. You had to be a double agent, both Mother-of-the-Year and Professor Moriarty, and my childhood was your secretly impossible mission.

And it was largely a solo mission, because after Dad died, all your schemes were complicated by the baggage and charged emotions that come with losing a parent.

If I'd had my way, following Dad's death, the ten-year-old me would've stayed inside and watched my VHS copy of *Ghostbusters* on repeat until the videotape self-immolated like magicians' flash paper. But you didn't let that happen.

You were always finding ways to bring me out, both physically and emotionally, and you were very, very cagey with your intentions.

Because if it had felt like you were "making" me do something, I would've rolled my eyes and hated it, but you were sneakier than that.

You made reading a normal part of our everyday life, and when I became more and more curious as a reader, even when I was exploring books that were far outside of my comfort zone, you let it happen. You let me explore.

As a kid, I was always taking classes and never knew why. I'd get jobs for the summer and I never knew exactly how I'd gotten there. We took trips, I got mystery internships, we'd see concerts and plays all the time. I had opportunity after opportunity handed to me on a silver platter and it never, ever occurred to me that there was a plan behind the

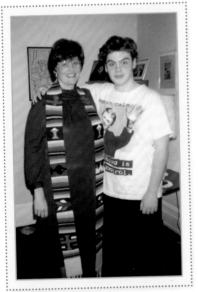

whole thing. I thought it was just life. I thought stuff just happened.

But that wasn't true, was it? YOU made it happen.

THAT is what being a mom is all about. That is the main parenting lesson that I've stolen from you and tried to apply to my relationship with my own daughter, your doting granddaughter.

It's not that I need to be some kind of *Giving Tree* messiah figure who gives and gives to his kids until it hurts. What I've learned from you is that being a parent is all about being responsible

for introducing your kid to the world around them. A good parent curates reality for their children. They gather up all of the good stuff—all of the knowledge, opportunity, existential wonderfulness, and more—and they say, "Here's what the world has to offer—go enjoy it!"

But kids, being kids, can't always take that advice. They're naturally suspicious, so, sometimes, the parents have to be sneaky. They have to find subtle ways to usher their kids into the weird, wonderful world, and like any good secret agent, they can't expect credit or commendations for their efforts. And, if I have a regret, it's that it took me way, way longer than it should've to pick up on the twist ending.

> *A good parent curates reality for their children. They gather up all of the good stuff—all of the knowledge, opportunity, existential wonderfulness, and more—and they say, "Here's what the world has to offer—go enjoy it!"*

So, in the end, it was Mom all along? Wow. I did not see that coming.

If I had to be raised by an evil genius mastermind, I'm so happy it was you, Mom. Thank you for your sneaky, endless love. I love you more than words can express and the human mind can fathom. You and me together? We're unstoppable.

Love,
Tom

Dear Mom
(aka Junie aka Junebug aka Mama),

People ask me all the time who it is I admire the most.

It's so typical for a daughter to choose her mother with that question.

For me, it's true, though!

I know you've given up a lot to have kids. You gave up your own career so we could have ours. You did without, so we could have whatever we needed.

You drove many miles to ballet class and piano lessons for me. You sacrificed so I could go to college.

Another question I get asked is how I can be so "tough"?

I have seen you battle cancer several times and come out the winner. I've seen you handle difficult surgeries barely complaining. You have shown me how to handle any difficulty with grace.

You have given me many gifts, but the most important one is easy: you told me to believe in myself always. You supported my decision to become an actress and a singer. You gave me self-esteem. (Not to be confused with arrogance.) Haha!

You have given me many gifts, but the most important one is easy: you told me to believe in myself always.

So thanks, Mama! There is no doubt I am yours and you are mine.

Love,
Kristi Dawn

Dear Mom,

My life has been great because of you. I love you so much. You're so sweet to me because you hug me and kiss my scrapes. I love when you tickle my back and sing me to sleep. You always know what to say when I'm sad. You take care of all my needs and encourage me to be the best I can be. I'm your biggest fan. Without you I would die.

Love,
Liam, age 9

Dear Mom,

I've remembered you in so many ways since you left. Yet somehow this single image reveals your essence more deeply than any of my memories. You would recall it as the one taken on your wedding day by Marie, your closest friend and bridesmaid. So candid and unguarded, it's the most compelling glimpse I've seen of the woman you were before I was your son: a striking young daughter in your mother's home on the cusp of marriage, with years of children yet to come. In this captured instant, all that would define you as a wife and mother lay ahead.

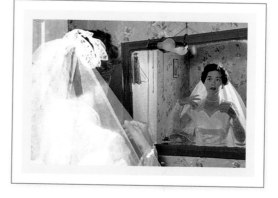

But on closer reflection, there may be hints of the future there. Maybe your quietly searching eyes in the mirror were echoed later in the soft curiosity of a gaze resting on your children. Searching for a glimpse of who we might become on our own winding journeys. Early and late, so much lived within that look of muted inquiry you held to yourself, as silent as it was penetrating. A subtle sense of wonder along with wondering; unspoken questions you asked of life as much as of yourself. And the shadow of a bittersweet acceptance of answers that came, chapter by life-changing chapter.

This is you on the biggest doorstep of your life. So many other doorsteps would be crossed and recrossed through the decades beyond. The births and departures of each of us, passing out of

the house after what must have seemed so brief a time since our first arrival. Born at the younger end of a long line, I watched you let us go one after the other, in a steady procession of graduations and marriages and removals to distant places. And with each release I unknowingly witnessed a reflection of the way your eyes looked in a photograph I would see only after my own passing through that door.

But here in black-and-white is a passage before all those later passages. I can see you appraising yourself as a bride, can feel your solitary, private pause in the crowded and surreal rush of hours that is your wedding day. As you see yourself as you are, on that cusp. The girl you once were standing invisibly behind you in this room of the house you were raised in, looking through your eyes. Something in you is saying good-bye to her; something in you is peering forward. Poised on the hinge of a life turned by someone you'd chosen, who had chosen you.

What else in this image speaks beside your dark eyes, wide as the breath you seem to be holding? Your hands lifting like birds nearing flight, a ballet pose of delicate fingers brushing back the veil from a luminous face encountering itself. Jet-black hair once seen flowing behind you in the midst of a horse-bound leap over a countryside fence, from a vision my father shared with me years after you passed. Silk dress against flocked wallpaper under a bare bulb—symbol of a lilac emerging from a vegetable garden, metaphor of you.

And someone else in the mirror too. Seen but not, yet. Suggested. My own eyes peering out of yours, mother. Recognized from countless gazes into my own mirrors, on the cusps of my own turning points. Each year I resemble you more, some say. An inheritance I grow into, a legacy of your stories somehow written on my face. If someday the wrinkles around my eyes look like yours once did,

I will read them like lines from a scripture I am still trying to understand.

So it is that this picture contains both memory and dream. It lives as a bridge connecting a woman who was with a man yet to be. A man possessing, he hopes, even a fragment of the soul you carried your whole life like robin's eggs in the woven nest of your heart. Holding with undying intention the fragile beauty of the world, and that which can live within it, against a gravity that pulls forever downward.

> Each year I resemble you more, some say.
> An inheritance I grow into, a legacy of your
> stories somehow written on my face.

I haven't fallen, Mom. You kept me aloft all these years, seen and unseen. I'll see you in the mirror.

Robert

Dear Mo

(your self-appointed nickname after I went from Cathy to Cat),

I want to start by saying thank you for adopting me. My birth mom Joanne gave me life and you gave me a home. I am so thankful that you and Dad were the ones to get me because you gave me more love than I could have ever hoped for. And besides,

I don't think any of those other waiting parents would have had the bandwidth to handle me. And at the low discount price of $350 you paid to adopt me in 1967, you got a hell of a deal.

Mo, thanks for showing me how to give back as you did so many times as a nurse practitioner. You helped take care of the sick, the old, the lonely, the poor, the mentally ill, and so many others. You did it as an unsung hero. Never asking for anything in return and never getting any glory.

Thank you for showing me how to be authentic. You never apologized for who you were. You held your head up high, laughed as loud as you wanted, wore what you wanted, and skinny-dipped, to our horror, without apology in front of your friends when we went camping. You dragged us to church every single Sunday when I know we obnoxiously whined, you dyed red Greek Orthodox eggs on Easter when all the other kids had pastels, and you always told us the truth even when it meant you had to deal with our backlash. And you never let us quit. Although I do wish you would have let me quit piano because all I could play was "Music Box Dancer" after 7 years of lessons. I guess you made up for it with all the cooking lessons.

This is my chance to say thank you for being different. For

being wacky and eccentric. You tried macramé, stained glass, wine making . . . you steamed artichokes when other kids had fried okra. You wore great muumuus and took us to New Age parties with all of your psychology friends where they served cheese fondue and sang around a circle drinking Mai Tais and Grasshoppers. I love that you "try on" life at every turn and are fearless. I wanted a normal family and thank goodness we never were.

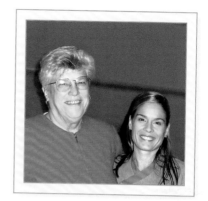

I love that you "try on" life at every turn and are fearless. I wanted a normal family and thank goodness we never were.

I thank you so much for being a best friend, taking my urgent calls filled with the latest melodrama of life, family, raising kids, love, and career.

You tirelessly listen, give gentle loving advice, and I am sure hang up, hoping your daughter gets it right.

Bottom line, Mo, you did a great job, look how I turned out! I say that without ego but with the knowledge that it has been because of the advice and example you have been my whole life. As a matter of fact, all of the Cora kids turned out healthy, happy, and went on to have our own beautiful families. And you were a wonderful wife to Dad, for 50 years.

So I honor you with my love and gratitude because of these things that you have taught me. I will never forget them.

I love you, Mom,
Cat

My Dearest Darling Mum,

When I look at a butterfly nestling on the tree or feel the little breeze on my cheek, I think it is a message to say you are with me. It has been seventeen years since you departed on your last drive from the farm in Argentina. There is not a day that doesn't go by

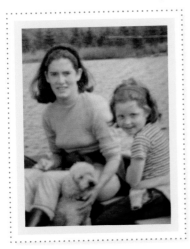

when I wish I could pick up the telephone and tell you what I have been doing, to tell you how your granddaughters have excelled and shine. They continually remind me of your magnetic energy and the humility with which you lived your life for sixty-two years.

So I am writing to you now, to say thank you from the bottom of my heart for the life lessons you have given me. People often ask me if I was sad and alone when you went to live in Argentina, following Hector, my stepfather, when I was 13 years old.

I look back now and thank you, forgive you, and love you more. You gave me the strength to look at life differently.

I am convinced I would never be the strong person I am inwardly had I not had to come to terms with the sense of abandonment. I wish for you to be looking over my shoulder right now, and realise that you gave me an empathy, which holds me in steadfastness and an understanding of belief in myself. I do forgive you completely. I am not angry, in fact I am sincerely deeply entrenched in gratitude. I cannot imagine what I would have been like without the knowledge of a deep feeling of loss after you left. Your journey taught me to rely on my inner self, and even now, as I write this, I am feeling more whole than I have ever felt.

Thank you, my Dearest Darling Mum, for your vibrance, for your beauty, for the way you glided like a swan when you entered any room. Thank you for jumping into the swimming pool with all your clothes on, for making Beatrice feel better after she let the dogs out, that

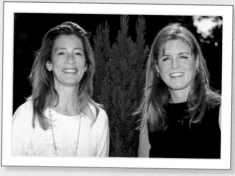

had to be separated as they fought. Thank you for making me the most proud daughter ever, and for teaching me about the finest things in life. That an upturned box, with a white sheet on it and a washed-out jam jar, can be the best vase for wildflowers on the now homemade table. You have given my heart a hug right now— just writing to you makes me know and feel close.

I wish for you to be looking over my shoulder right now, and realise that you gave me an empathy, which holds me in steadfastness and an understanding of belief in myself.

You loved Andrew so much, and your darling granddaughters, they are all exceptional, and I pass your photograph every day and say I am the luckiest girl in the world to have you as my Mum.

The sun is going down here in the UK, and the evening light cools the earth, and thankfully, because of our golden memories, the sun never goes down in my heart for you.

Thanks, Mum, I love you, I miss your physical presence, but when I next see a butterfly, I will know you have read my letter, and that you are proud of me and my girls, and of course, your special son-in-law Andrew.

Wow, we always laughed, didn't we? I never stop laughing and feeling full of joy, because then I know you are near.

Your ever loving and devoted daughter,
Sarah. Your Fishface. X

Dear Mom,

I don't often tell you how grateful I am for all that you've done for me. You're busy, I'm busy, and stopping in the midst of it all to say thank you can feel awkward, too formal, a little bit uncomfortable even. It seems like a sacred task for some day

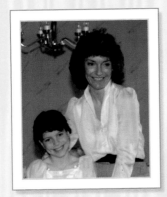

in the future—at a special occasion, maybe, where you're feted with a cake and candles and flowers and balloons—not here and now.

But since I've been given this chance to write a letter to you for all the world to read, let me say it: I recognize, and am deeply grateful for, all the sacrifices you made for me. You were raised Iowa-Midwestern and strictly Catholic, and nothing in that background prepared you to be a divorced single mother at the age of 32 with three little girls under the age of 6. I know, as a woman of 38 who struggles to balance her work and her relationship and all the quotidian demands of life, that supporting a family all by yourself could not have been easy. I think of you at the kitchen table, studying nights for your MBA after working all day at your secretarial job, while my sisters and I hollered and flung jam in each other's hair and clamored for attention, and I wonder how you did it. (I can't even write with the television on.) I remember those years when money was scarce as you climbed your way up the proverbial corporate ladder—sometimes we had to borrow hot lunch tickets from the school secretary—and I marvel that you weren't consumed by anxiety and worry. You must have felt daunted at times, yet you never let on. To a child, this was a magnificent gift. We always felt safe and secure.

You worked so hard not only to support us, but also to give us the opportunities you believed we should have: ballet classes,

math tutoring, summer camps. Some of this private instruction was rare in our middle-class milieu. I don't think anyone else at my public high school took a Princeton Review SAT class, and how we managed to scrape together $800 for one—a hefty sum for us in those days—I have no idea. But from the beginning you had the highest hopes for us, and you made every effort to see them realized. While you were pregnant with me, you read me classic Russian novels aloud. ("That explains *everything*," a writer friend once joked.) When I was a baby, you wrote nouns on flash cards and taped them around the house (the lamps, couch, stove, windows—all labeled), pronouncing the words for me as you cradled me in your arms. During my adolescent years, you had a job as an event planner, and you took us on work trips with you so that we would have a taste of places beyond the Midwest. In Puerto Rico, we left the fancy but boring resort hotel to see an artist's studio and eat traditional cuisine. In North Carolina, we visited Duke and Wake Forest Universities, and afterward picnicked while listening to a symphony on a vast green lawn. In Sedona, we drove through the dusty red-rock desert to visit a psychic.

I've rarely thanked you for these precious experiences, but please know that each one played a part in making me who I am. Together, they also made possible what truly seemed inconceivable back then: my admission to Harvard University. At my public high school in suburban Illinois, going to an out-of-state college was uncommon; going to Harvard was practically unheard of. But you encouraged me to apply, and with scholarships and savings and financial aid, we found a way to cover the tuition. You taught me to dream big: if you can imagine it, you'd say, you can find a way to make it happen.

Most of all, though, I want to thank you for being you, and for showing my sisters and me what it means to be a strong woman. You never uttered the word *feminism*, but you sure lived the idea. There's a lot of talk these days about having it all, doing it all, being it all, and how oppressive this notion is. You have always been smart and beautiful, hardworking and loving, feminine and tough, eccentric but grounded. You made me believe that one doesn't have to choose among these qualities. You made me believe a woman can be whoever she is, in all her glorious contradictions. I remember you turning up at my school events, fresh from your workday, dressed not in dowdy mom-clothes but in glam '80s-era office attire (shoulder-padded suits, bow-tie blouses, pantyhose, pumps). I thought you looked like a movie star, and it made me proud. I also remember your lighthearted, casual weekend-self as you burned incense, read spiritual literature—you were always a seeker—blared Jimmy Buffett songs, and danced around our house. You weren't a traditional mother, but you were an original one, and you made me the original woman I am today. ("Odd," you sometimes say, with bemused affection. I take it as compliment.) I wouldn't trade this for all the cookie baking, room-mothering, or Girl-Scout-troop-leading in the world.

Thank you for all that you've done, Mom, and for all you are. I hope you know how much I love you.

Love,
Amanda

GLORY GALE

Kathleen Verplancken

A note to my Mama:

What a child you've raised: a lazy, uneducated, mooching child. And although I spent most (or all) of my youth sitting in front of a television, never helping in the yard, outright refusing a (real) college education, and only started paying (the majority of) my bills late into my mid-twenties . . . I think I turned out pretty well. Better than well—outrageously fortunate.

Fortunate to have you, and to have been shown that life, good or bad, is always an adventure.

You're my "business mom," focused, hardworking, setting goals and resetting if you have to. You've owned your own business for almost four decades, through which you've found a way to employ every relative who blew out from the Windy City and found your door in the Sunshine State. For a while you decided to get a real estate license, studying late into the night even though you'd already worked a nine- or ten-hour day. Eventually you dropped Realtor from your business card, although it didn't take long before you added another profession to follow your name. Caterer may be an inherited enterprise, but it's one I know brings you more joy as the creative human being you are. That's why it's no surprise you've put it to good use making sure the veterans in our little community get hot meals on a regular basis.

So maybe it makes sense that in all of that, your best, and my favorite, trait goes uncredited.

39

My Mama, you're one of the funniest people I know, and not in the (painfully) obvious way like politically incorrect jokes or off-color one-liners. Your humor has its own sense of timing, voices that come from thin air, impressions of people who didn't use their best sense, your use of the word "gurl." And because it's a trait no one ever seems to notice, I've managed to claim it as my own, thereby stealing all your comedic glory.

When was the last time you were given credit for having such an infectious laugh? That laugh that often reduces you to tears long before you've finished retelling the story? Sorry, Ma, seems like I stole that too.

In school I wasn't the popular kid, the pretty girl next door or a prodigy of any fine motor skill. I was bullied, picked on, and was never ready for school. Sometimes my struggles seemed to find you stumped, but you always had a plan.

Like your morning wake-up call, "Oh whoopee! It's gonna be a great day!" Your own version of singsong and a message that

(after the fact) seemed to say you knew I could handle anything, but I needed to get up and try. It was a melody that saw me through both junior high and high school, and even now, it's a song I catch myself humming when 7 a.m. is too early.

Then there's the way you handled the unexpected. Like the time you found me in the ICU, admitted under an alias after a serious accident: "Well, at least nothing got your face." Words I won't ever forget because in that state of groggy unknowing how the

rest of me looked (or if it had even survived) the calm in your own sarcastic relief, and your expression during your own "pieces and parts" check, was all I needed to know I'd be fine. My sigh in seeing you was better than make-believing it had all been just a terrible dream.

Recovery was long; ten years later it sucks to have said good-bye to my (imaginary) Radio City Rockette career, but I'm more fortunate to have been able to come home to you, albeit a little worse for the wear, but alive after an unexpected, and very dangerous, adventure.

[*Sometimes my struggles seemed to find you stumped, but you always had a plan.*]

So for a woman not entirely sold on the notion of having a child, I'm certainly glad you did. Having children is a sacrifice, especially for a woman used to her independence. And while at the time your biggest sacrifice may have been your thousand-dollar suits (and the pilot's license), I hope you've found you haven't missed them anyway.

I love you so very much, my Mama,
Your Child

Mom,

You have thrown yourself into your role as mother with unrestrained dedication since the beginning. You schlepped me to more activities than I can count, rooted me on in every event, proofread homework and hand-sewed Halloween costumes. You cooked and cleaned, planned vacations, helped research colleges, and did a million other things, too numerous to count. When I finished school, got married and started a career, you probably thought your work was mostly done, but in some ways I've relied on you more than ever in the past 11 years, since becoming a mother myself.

You've stayed on the phone with me in the middle of the night as I cried right along with my colicky baby. You've helped me navigate the tricky waters of having a child with some special needs. I know I can call at any time and you'll always be there for me.

But, I don't think either of us foresaw this latest call for help. It's been a whopper. Cancer. Stage IV. As I go through this, the toughest part has been watching the toll it's taking on my kids. I am disappointed that my life has been derailed by cancer. Initially, the thought that I may not get to do some of the things I'd always planned and expected to do with my life upset me, but I've adjusted, understanding that my life may take a different path than I anticipated. Really the only thing I can't adapt to is the possibility that my kids might have to grow up without a mom, that they might have to experience a suffering or loss that I can't shield them from. This devastates me. The thought of any real harm coming to my children devastates me. One of the only things that I can imagine more difficult than getting an incurable diagnosis like

mine is for me to witness one of my kids getting it.

And, yet, I realize, that is exactly what has happened to you this year. And you have stepped up to the plate big-time.

People have called me brave and strong and all sorts of other flattering things this year. But you, in the background, you have stepped up more than me. At a time when you should be past the difficult mothering tasks and reveling in the gravy that is grandkids, you're back to nursing your baby. By my side whenever I've needed you these past five months: flying up and back without complaint in spite of your fear of flying; sleeping in hospitals and on couches in spite of your back pain; talking with doctors, researching treatments, driving me to appointments, cooking and cleaning, doing my laundry. The list of things you do for me is as endless as ever, and I am grateful.

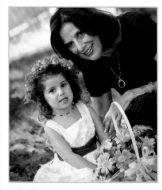

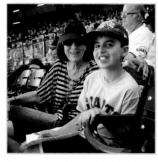

But the thing for which I am most grateful is something that has really surprised me. It's your positivity. I don't think it's a secret that you're a worrier. Worrying is a specialty of yours, an art. Worst-case scenario is your jam usually. I would have guessed that a diagnosis like mine—an actual worst-case scenario—would send you into a tailspin, and with good reason this time. But it hasn't. Turns out, when the chips are down, you do what needs to be done, as you always have, even when it means figuring out a new way to be. Without being artificial, or Pollyannaish, you've helped me keep my hopes up. You believe in my future, and help me believe. Whether you instinctively knew this was what I needed, or what you needed yourself, I'm not sure. But from the bottom of my heart: thank you. Once again, as always, you are there for me. I'm not sure how I could navigate this without you. I couldn't be a more grateful daughter.

I love you.
Lisa

43

JOSH GROBAN

Lindy Groban

Dear Mom,

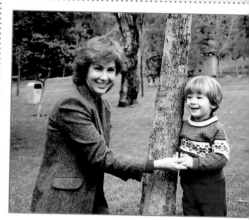

You had me on February 27, 1981, after 12 years of marriage to my wonderful dad and 39 years of a blissful child-free life! You and Dad explored the world and enjoyed loving each other without the constraints of a whining, pooping, uncoordinated attention fiend. You waited because you KNEW that when you became a mom, you wanted to be the best mom of all time. I want to thank you for waiting and for succeeding. Raising me wasn't easy. I was odd, I was hyper, and sometimes I spoke in my native Martian tongue. But you were ever-patient, ever-loving, and emotionally connected to me in that way that was telekinetic. As an art teacher and art lover you exposed me to a world I now feel fortunate to call my home. As a realist you never let me dream without the steadfastness and work ethic to back it up. You wanted me to achieve those dreams. You taught me to embrace life with openness and wonderment. You also taught me how to embrace the dark and how to learn from it. As I write this I realize it has been written in past tense. Mom, your light is past present and future. And my laziness about rewriting things is eternal.

Thank you for being you and for making me.

Love for always,
Josh

Dear Mami,

I am not positive how heaven works. Everyone tells me you are watching down on me, but let's face it, if heaven really is a perfect place you're probably watching your telenovelas. Better yet, running down the sidelines of a soccer game, yelling in Spanish with nobody understanding a single thing you say. Yeah, that sounds more like your kind of heaven.

But hey, it's OK if you're not watching us all the time. I think we are starting to get the hang of things around here . . . at least we pretend to. I certainly do. I have a great job, great friends, great love, but no matter how much I have, I always think about what I don't have anymore. You. To say I miss you would be the biggest understatement ever uttered. I long to be next to you, to share my successes, and to pit my follies. To hold your hand, and hear you tell me that you are proud of who I am. I hope to damn you are.

And there it is. The heaviest cross I bear. The constant concern. The wallowing worry. The question I ask too oft, "Would you be proud?"

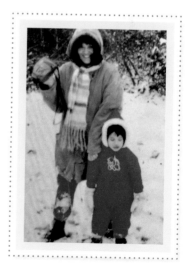

You were my best friend. My rock. My teacher. My hero. Yet, the most important role you played was my source of validation. The first person I looked for when I scored a goal. The hug I sought when I aced my test. The smile that told me that I had done right.

When I graduated high school, and walked across that stage, I held up a sign that said "I love you mom." I held it in hopes that in some way, somehow, it

would catch your attention, wherever in the universe you may be, and I would feel that presence, see that radiating smile, and know beyond my doubts, and above my concerns, that I had done good.

It's not that I don't believe in myself, I do. I just wish I could hear you say it, one last time. That you were proud of the man I have become. That I stayed true to your raising, embodied the lessons you taught me, that I'm who you had hoped I'd become.

I mean, I still bite my dinner mints before I eat them, you know, so I don't choke. My dentist hates it, but I told him, "Mother knows best." I think you'd be proud of that. Or maybe that like you, I still wake up every weekend morning singing and dancing my heart out. And like I promised you, I will always love you.

"I'll love you forever, I'll love you for always."

Just like the book. I have it tattooed across my chest, so that every time I look in the mirror, I see a little part of you.

"I don't like you . . . I love you," you'd say as you changed the words and read them to me every night, "as long as I'm living, my baby you'll be."

And I will never forget that one night, just days before you passed. You called me to your room and demanded that I sit on your lap, just as I always had. At first I refused, your poor body weakened by the cancer, but you insisted.

"My baby will never be too big for me," you said.

So I sat there on your lap as you read me the book one last time. And as we got to the end, where the mother is too weak to carry her son, you looked at me, with tears in your eyes, and asked if I would please read you the last page.

"I love you forever, I love you for always, as long as I'm living, my mommy you'll be."

And I mean it. Whether you are watching me or not, I won't ever stop loving you. I will always keep my promise, just as you always kept yours.

I guess that's something you can be proud of.

Te quiero mucho, Mami,
Your baby

MARIEL HEMINGWAY
······································
Byra "Puck" Hemingway

Dearest Mom,

So much has happened and you
haven't been here to see it. So I decided
I am going to show you in this letter
a little of who I am and how much I
appreciate who you were.

I am happy now and I think that
happiness is attainable. I would like
nothing more than to share with you
the joy I have found for living. When
I was 12 and performed the Joey
Heatherton Serta Perfect Sleeper
mattress commercial for you until you
couldn't breathe from laughing so
hard—that is the kind of uncensored

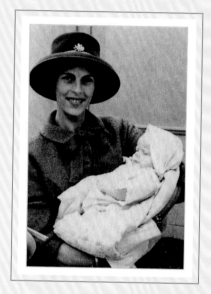

joy I feel daily. I loved entertaining you. You were the best
audience ever. Those times I did skits for you while you lay sick in
bed were the times that made me believe I could be a performer,
that I could make people laugh and cry because you could see me.
Now when I laugh and play I do it in honor of you.

Mom, you lost the hope that joy existed. You were lonely and
sad. You couldn't connect to Daddy because somewhere along
your path you let your acceptance of him and your life together
disintegrate. You wanted to love him, but hard life, drinking,
and losing the love of your life before you met Daddy took your
dreams away. You never spoke of your pain and how disappointed
in the world you had become. I felt it and your body was crushed
by it, the resentment you held inside showing up as cancer for
over two decades. I know in my heart of hearts that you wanted

47

to smile, to let go and not judge, but you had too much invested in the hurt, which became your life. It was too hard to turn it around. I understand because for 24 years of a marriage I did something similar, becoming who I was trained to be, not who I was. I was sad too, disappointed, not connected and unable to communicate. Inside I wanted to be different and have my loved ones really see me but I too had invested in my story where the main character was a martyr.

You'll be happy to know that I garnered the courage to change, and seven years ago I left that life to spend a couple of years feeling what it was like to be me by myself. Five years ago I met my life partner Bobby. I love him deeply just the way he is because he loves me just the way I am. Together we grow, challenge one another, and every day we laugh. Were you able to see us, you might just want to come and sit in the hammock and watch us climb ropes, rocks and jump on the trampoline (just like I did in our backyard). Today I jump, flip, and giggle and I don't watch the kitchen window in hopes that you'll come watch me. I feel good about knowing the attention I get that matters most comes from me now. Oh how I wish you could feel that . . . to feel love because it comes from inside. It is an extraordinary thing to love oneself.

You never felt that, and you so deserved to. Never would I have thought I would like myself, my life, and how I show up in the world. It feels like freedom.

Your life was a sacrifice, a life given for others to get what they needed so they could move forward either failing or finding joy. Your own happiness you gave up on so that others' lives could matter. Please take this opportunity to hear me in my joy and know that you were good . . . a good woman, and a great mom. You raised three girls, two got lost because their circumstances were heavy and confusing. Just so you know, Mom, it was not your fault . . . you nurtured like mothers should and sometimes our children have paths that are not in our ability to orchestrate. I know you wanted the best for us. And for me you brought me close no matter how sick you were. I slept with you from age seven on. I had such terror of something I couldn't put words to and you never questioned it. We know why and I thank you.

I miss you. I miss who you could have been had you known what I know now. Smile and spread those skinny arms of yours attached to those beautiful "capable" hands and take me and your granddaughters into your soul. We are fine. You told me right before you died that I was a good mother and that meant so much to me coming from the best mother I could possibly have had. You are in my heart, you are my guardian angel . . . I know that for sure. Being in such a famous family, it must have felt like you were inconsequential, but that is not at all true. You are the soil beneath my feet. You are my first teacher and most importantly you are my own sweet and delicate mommy.

Love,
Mariel

LISA HIRSCH
................
Ruth Elian

My Mom, My Hero:

Mom, as I sit down to write my letter I wonder how I can possibly start to share all my feelings with you. So much has changed since you developed Alzheimer's ten years ago. As I gather my thoughts I realize that you will not be able to comprehend most of what I say.

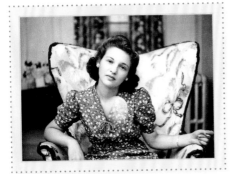

As a teenager I loved you, yet somehow I wanted one of my friends' mothers to be my mother. Then, after you became ill I fell so deeply in love with you. An unconditional love was born and since then you have inspired me each and every day.

I'm not really sure why my sentiments changed so drastically, I just know that I was given a second chance to feel a deep love and appreciation for you. As I reflect back through these years, you have inspired me and have become my hero.

Your humor, your smiles, your sweetness have melted my heart. In several months you will be turning 90 years "young." You can still be feisty, and as you run around in your Merry Walker, I wonder what you could possibly be thinking. Of course I could ask you, yet as silly as that might seem you would not be able to remember anything.

Before you entered the nursing home this past August I spoke to you every single day. We ended each call throwing each other our kisses. I have continued to phone you at the nursing home every day.

Most of the time you say hello, and after a minute you just drop the phone. Recently I was able to catch you when you were having a minute of clarity. You sounded free of Alzheimer's as you shared

that you missed me. These words immediately melted my heart. After hanging up the phone I knew that this was a magical moment, an occasion for me to treasure.

Mom, I am also a mother. My son, your only grandchild, is 26 years old. You adored him and yet today you no longer remember who he is. There have been times that you think you have seven children and days when you think you have none. As a mother I cannot envision that one day I might also not know that I have a child.

I find it hard to believe that a disease like this can wipe away your whole world as if it never existed, leaving your mind a blank canvas. Daddy passed away almost twenty years ago and I do not believe that you have much recollection of him. I'm actually happy that he is no longer alive. I cannot imagine the pain he would have endured watching you fade away.

Our roles have reversed. Now it is my turn to care for you as you once cared for me. I brush your teeth, comb your hair, feed you, and dress you.

But the truth is, Mom, that no matter whatever you can or cannot do, I am still your daughter and you will always be my mother.

Life is strange; for out of you becoming ill I have discovered a whole new world. I was given a second chance to love you unconditionally. You have opened my heart to such a deep compassionate love. I feel honored and I am so proud that you are my mother.

Your one and only daughter,
Lisa

51

SUSAN NIRAH JAFFEE

Joyce Marlene Jaffee

Dear Mom,

Since you've been gone I've been celebrating two birthdays—my actual birthday, the day I was born, and my re-birthday, which is also your "deathday."

When I boarded that plane in Los Angeles to be with you for your last month here on Earth, I thought to myself, "There's nothing more profound than helping the person who brought me into this world, out of this world." Having never given birth, I

had the notion it would be like some kind of "reverse labor." But, as it turns out, it was exactly the opposite. In fact, I was reborn. Every minute I spent with you, right through the very moment you crossed over, I grew—not in cells and tissues and organs, but in character and spirit and purpose. Although your body was winding down, your soul was blossoming. You were more open than you'd ever been. More vulnerable. More talkative. More honest. You even seemed to laugh more.

Our last few weeks together we'd have our "parties." We'd drink champagne and eat your favorite foods. Caviar, smoked salmon, escargot. At first you would share stories about your past that I'd longed for years to hear. You'd lavish me with praise, rather than strip me with criticism. The fight you had when you were "healthy," which blocked our path to real intimacy, gave way to surrender, as you entrusted me to bathe, clothe, and change you. Then, as you neared your transition and the veil was thinning, you gave me the gift of peeking through to the other side. You talked about the crowd of people in your

room, loved ones, and even strangers, who had long since passed away. Your eyes were bright and your smile wide—you were practically giddy—when you spoke of the powerful peace and love you were experiencing shortly before you slipped off into the unconsciousness from which you would never awaken.

In sharing your death with me, Mom, you gave me a new life. Suddenly, when I returned to Los Angeles, the life I had been living was no longer compelling. Until your death, and my rebirth, I firmly believed it was my occupation which defined and validated me. I had convinced myself that it was my LIFE. To put it another way . . . when you died, a big part of me died with you. It was the part that put my creativity, happiness, and self-worth into anyone else's hands but my own.

Together we transitioned into new states of consciousness. Because you so boldly embraced dying, I now embrace life.

I live in the present, and I'm excited by change instead of frightened by it. I don't sweat the small stuff anymore. Hell, I don't even sweat the big stuff! I'm just grateful for any stuff at all. (Experiential, not material.) One of my favorites is, sometimes I'll see something, usually in nature, and even if I've seen it a thousand times before, it's as if I'm seeing it for the very first time. And most important of all, I never ever pass up an opportunity to tell someone close to me, "I love you."

It's hard to believe this July 23rd, I will have been alive for fifty-two years. And next March 18th, I will have been living for four.

I miss you, Mom. I always will.

All my love,
"Susan Busan"

Mami,

Gracias por enseñarme a amar sin ver el color. You taught me to love with my heart. You led by example as a Latina who fell in love with my African-American father just a couple of years after it became legal to do so in 1967. You said we owe thanks to *Loving vs. Virginia: The Case Over Interracial Marriage* being overturned.

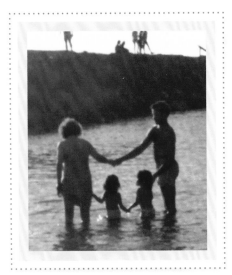

Prior to this date, it was illegal to marry interracially.

Walking the streets, eating at restaurants, or on outings, people would hurl nasty comments about your relationship with Dad. He held your hand tight, the same hand he would later take in marriage.

When we were born, you tried to cover our ears from the derogatory statements people would say about your multiracial children. Instead of running from it, you explained that not everyone is mean and we would surround ourselves with those who loved and supported us.

In grammar school when kids were nasty toward us because we looked different than them, you said to focus on what we had in common, not our differences. When kids laughed at us for bringing ethnic food to school instead of peanut butter and jelly, you taught us to be thankful our grandma woke up early to make us a home-cooked meal.

In middle school during the '80s when we hated our curly hair, you reassured us that women were paying big money for perms that looked like ours. We would cry to you that there wasn't anyone who looked like us. You told us that it didn't matter what the outside looked like because on the inside we are all the same.

In high school when I wanted to start to date, I asked you whom I should date. You told me you couldn't tell me whom to date but that I would know by how he made me feel.

In college during rush week there wasn't a multiracial group to join so you encouraged me to join both Black and Latino Student Unions. When I called crying saying I'm not Black enough or Latina enough, you comforted me from miles away and you told me that I was enough. And I believed you.

> *When I called crying saying I'm not Black enough or Latina enough, you comforted me from miles away and you told me that I was enough. And I believed you.*

As an adult I fell in love with a Korean man. He asked me to marry him and we had your grandchildren. I told you people would look at me, then at my kids, then back at me, wondering the connection. Was I their mom or their nanny? I asked you what you thought and you said, "What do I care what they think, you know who you are to them, don't you?"

On international day at my daughter's school, she came up to you and said she was so sad because each student had to stand up and say what cultures they were. She stood up and said Latina, Black, and Korean. She said she thought she had the most cultures but her classmate Michael had four cultures!

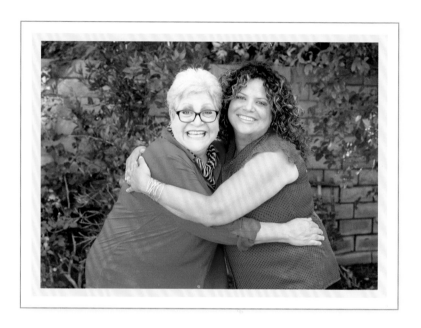

You laughed, held her hand tight and said you were happy to be alive to see the day when your grandchildren would hold their head up high and be proud to be multiracial.

Yes, Mom, I'm the product of an interracial marriage in a multiracial marriage with four children who we are raising as mini global citizens in this diverse world of ours. My children will inevitably come to me with the same feelings and ask me the same questions I asked you. But I know from your teachings I will be able to help guide my children as you did for me.

Gracias, Mami, for following your heart and marrying Dad, thereby showing me that love conquers all barriers.

Sonia

KATRINA KENISON
..
Marilyn Kenison

Dear Mom,

I don't often stop to think about it, yet you are the one who's been right here, at my side and on my side, from the moment I drew my very first breath. There's no way I can do justice to that kind of lifelong presence in a letter. But if gratitude is the memory of the heart, then at least I can remember some of our times as mother and daughter and, in the act of remembering, say thank you.

I remember the bracelet, dark red and blue shoe-buttons strung on elastic, that I made for you in kindergarten, the first Mother's Day gift fashioned by my hand. I remember seeing it tucked in the corner of the jewelry box on your dresser where you kept it for years, loved and treasured if not worn.

I remember that I could not, would not, put my face under water at the pool. I remember that you didn't make me do it. I remember two small Dutch dolls, a girl and a boy, with wooden shoes and painted faces. I remember you gave them to me on a hot summer day for no reason at all, except, perhaps, because that was the afternoon when I finally coaxed my terrified self all the way into that pool.

I remember the first deliberate lie I tried to get away with—"the cat did it"—and how you saw right through my five-year-old fabrication and gave me time to figure out for myself that the truth would be better.

I remember soft pajamas with feet and Sunday night suppers served on TV trays in the living room. I remember Welsh rabbit on saltines, milk in gray speckled plastic mugs with brightly colored rims, *Walt Disney's Wonderful World of Color*, and a bedtime that was the same every night. I remember you singing in the darkness, all the words to "Mairzy Doats" and "Tell Me Why the Stars Do Shine." I remember wishing the lullabies would never end, that you wouldn't leave my side, that the day didn't have to be over.

I remember a bright pink corduroy jumper that you sewed on the green Singer, and a shirt with daisies growing up the front, and playing dress-up in your filmy blue nightgown and pearls, tottering

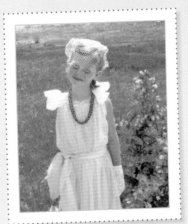

down the driveway in your shoes, feeling like a princess in your grown-up things.

I remember watching you stuff turkey after turkey after turkey, a lifetime's worth of turkeys roasted and holiday meals served and cleaned up after.

I remember finding your most precious books in a chest in Grammie Stanchfield's attic, studying your careful, girlish penmanship. I remember the shock of seeing your maiden name inscribed all those years ago on the faded inside cover of *Black Beauty*. I remember being stunned to realize that you had once been a little girl yourself, and that you had had a whole, complete life before me.

I remember that you always called your mother on the day of the first snowfall of winter. I remember the day you lost her.

I remember the first bra you bought me and how embarrassed I was—by the color (red!!), the name ("Little Me"!), the prospect of wearing it, the very possibility of breasts.

I remember how good you looked on a horse. Back tall and straight, hands quiet, heels down. I remember how nervous you

were about riding and that you did it anyway. I remember the day you flew a plane by yourself. I remember thinking, "I will never do that."

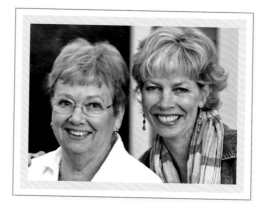

I remember confiding in you ahead of time that I was going to sleep with my boyfriend, and then realizing that you might have preferred not to know. I remember wanting to tell you all about it the next day and forcing myself, for your sake, to keep quiet.

I remember going out to lunch, just you and me, the day before I left for college, ordering a drink, and feeling sadness and excitement all mixed up together, already missing you on the one hand and, on the other, just itching to be gone.

> *I remember all the ways you have loved and cared for my children these last twenty-four years, how joyfully you became a grandmother. I remember how much I've needed you to help me through the hard days of motherhood.*

I remember the two of us, eating lobster and drinking wine, two nights before my wedding. I remember how much fun we had picking flowers and making bouquets for every single guest room. I remember a moment just before the ceremony, when we stood in my bedroom and said something that felt like a good-bye and a hello at the same time. I remember your funny, relieved curtsey in the kitchen on the morning after, when every wedding task was

done, and I was finally married to the right man, and you could relax at last.

I remember when my first baby was born, how you somehow managed—despite your dread of city driving, despite not having any idea where the hospital was—to get there anyway, to be right at my side when I became a mother myself. I remember how completely, utterly glad I was to see you.

I remember all the ways you have loved and cared for my children these last twenty-four years, how joyfully you became a grandmother. I remember how much I've needed you to help me through the hard days of motherhood. And how, when there is something wonderful to report, you are always the first person I need to tell.

I remember—and I know this still—that you have always believed in me, even when I couldn't believe in myself. I remember so much more than I can say here. May I always remember to keep saying thank you!

Love you,
Katrina

LAUREN KEPPEL

Amy Wagner

Dear Mom,

Given the roller-coaster ride we've been on lately, I thought it might be a good time to put some of my feelings down on paper. The day you told me you had been diagnosed with terminal ovarian cancer, I think I literally felt time stop. I can remember the exact moment, the room spinning and me looking at you thinking, "NO. I'm not done yet, *we're not done together yet.*"

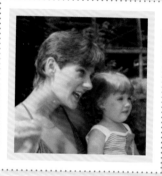

In the year and a half since then, our lives have changed completely. Wrapping my head around the knowledge that this cancer is ultimately what will separate us—be it in three months or three years—has taken time and has turned out to be both a blessing and a curse. At times it gives me this beautiful ability to be more present in the moment than I've ever been before and to see things simply for what they are, and other times I find myself desperately grasping for the ability to predict the future—to know when, where, and how. But, because of your influence, on most days our family opts for the former—to open our eyes to the gift that is this time together, to find out what it really means to live out your motto "*dum vivimus vivamus*: while we live, let us live."

People keep saying that we're brave, or that it's remarkable that we've chosen to handle this journey in the way we have. I've had a hard time understanding that—it doesn't *feel* brave or remarkable—and I've wondered why that is. Recently it dawned

on me: it's because *this,* this very grounded, open approach to life's phases and changes, is the essence of who you are and what you've taught me since the day I was born. You are the barometer of our family, the leader of the band, the soft place to fall, and the pulse point.

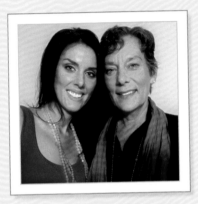

Throughout my life you've always told me about the words you whispered to me during our first moments alone on the day I was born.

You told me that although we didn't know each other yet, you were certain we were meant to share great things. And that even though you sometimes felt like you were still figuring out who YOU were, you promised to give me all that I would need to discover who I am.

You promised to love me completely, to always see me for who I am at my core, and to teach me to listen to my heart. Mama, I want you to know how perfectly you kept your promises.

[
You promised to love me completely, to always see me for who I am at my core, and to teach me to listen to my heart. Mama, I want you to know how perfectly you kept your promises.
]

I am so thankful that I was chosen to be your daughter. It amazes me how even now, during some of your most painful times, you still manage to be the one comforting me; the grace

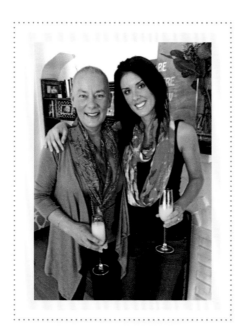

you're showing on this crazy cancer ride fills me with such pride to be your family.

 You were right that day, Mom. We WERE meant to share great things together—we've been sharing them every day for the last 32 years. Every early morning phone call, every silly dance party, every giant Sunday dinner, and each of the moments in between. And I see now that my fear on the day you were diagnosed, the panic that "We're not done yet," was unfounded. Because of you, I understand now that we will *always* be together, that I will always be able to feel you and know that you are sharing in my experiences, wherever you are. I want you to know that I'll be okay, Mom. No, more than that. I want you to know that I will thrive, *because I am a part of you.*

I love you,
Lauren

ALI LANDRY
Renella Landry

Dear Mom,

As I sit down to write this letter to you I fear that I may not be capable of expressing what you mean to me with words. Tears are welling up as I begin because you are, and always have been, my everything. I look at my life today and I am completely and

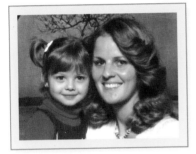

utterly my mother's daughter. I can't help but laugh because I can remember times, growing up, when I thought you were so unfair with your constant worry, strict curfews, and endless questions about who I was with and where we were going. Naturally, I now realize that all you were doing was your job as a loving, protective parent who wanted the best for me and

I am proud when I recognize those same qualities in myself. You seemed to balance your work, our family, great friends, and three children with such grace that your example inspires me daily and assures me that I can do the same.

I was at Estela's dance recital the other day getting her ready for her first performance and it brought me right back to the times you spent with me backstage, making sure my costumes were all together, and sticking so many bobby pins in my hair, to make sure that my headpieces wouldn't fall off, that my head

felt like a pin cushion. You would be proud to know that I was the one handing out the bobby pins to all of the moms backstage this time. :)

I want to thank you for all of the sleepovers you let me have,

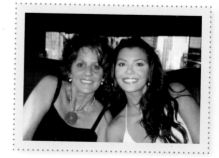

for letting me eat grilled cheese sandwiches for breakfast, lunch, and dinner, and for making the most creative Halloween costumes and class projects that always won first place. I want to thank you for always giving such great advice to all of my friends, for running me around to dance class, cheerleading competitions, volleyball practice, and student council meetings.

Thank you for being the most AMAZING Grandmama in the whole world! I have so much joy in my heart when I see you with my children that it feels like it is going to burst. My favorite thing to do is just to step back and watch you interact with them. It is the most beautiful thing I have ever seen and I am so thankful that you and Estela have such a special relationship.

One of things I admire most about you is how much you help others. All of your friends and family depend on you for so much and you show up for everyone. I so love that about you. I'm also constantly amazed by what you can accomplish and what you are capable of! It's almost like you have some kind of superhuman power. You can do anything from laying a hardwood floor and grouting tile to making the sweetest baby clothes for my children and EVERYTHING in between.

I really could go on and on about how incredible I think you are and how much I admire you but I will close by saying that "I love you" will never be enough to express how I feel about you.

You are my guardian angel on earth, my beautiful, talented superwoman.

You are my best friend. I am honored to be your daughter and I always want you to know how loved and appreciated you are and how much you mean to me. Even though I am a wife and mom myself, it is still very clear to me that I will always need my Mama!

Love,
Ali

MICHAEL LEVITT

Marian Levitt

Mom,

It's me . . . your son . . . or as you like to call me by the Yiddish term of endearment, "your Little Pisher."

It all started when I was born in Roswell, New Mexico. Our family was dirt-poor, and as the story goes, we migrated west to California to start a new life when I was just eight days old. The car was so full of stuff, the only place for me was in a little tiny baby bathtub in the backseat. So while the early settlers moved west in covered wagons, I should have known my life was going to be different when I moved west in a bathtub!

While Dad was struggling to put food on the table, you, on a modest teacher's salary, provided for all four of us kids. Never did I feel without. There were always clothes, food, activities.

As you and Dad started to get back on your feet, making a decent living, we never indulged in excess. I was the kid that had Le Tigre when everyone else had Izod. We were the family that was getting Pong when others had Intellivision. But that was okay, because while I wasn't showered with material things, I was showered with love and affection. I always knew that you and Dad were my #1 fans, always there to support me, instill confidence in me to take on this world, and root me on in whatever I was doing.

I'll never forget growing up when I was being bullied by a mean kid up the street. I came home from the community pool hysterical. Without a beat, your mama bear instincts kicked in and

at lightning speed you ran by foot to that local pool to get right up in that bully's face and let him know if he ever teased or touched me again, you would . . . well . . . you would kick his ass. I was in awe of you, my Super Mom, and knew that you always had my back.

In high school, as I was starting to realize my sexual orientation but was so afraid to tell you and Dad that I was gay . . . it was YOU that "out'd" me! I'll never forget the day you sat me down in the kitchen and said, "Michael, your dad and I know that you are gay. We don't want any secrets in our family. We love you and you will always be our son. We want to make sure you are being responsible and practicing safe sex." I couldn't believe it. How many parents come to their gay children and out them! And the idea that you wanted it out in the open and wanted to reaffirm your unconditional love and make sure I was being safe was such a beautiful and profound moment. My favorite part was when I asked if you were disappointed and you said, "Well, I was looking forward to dancing at your wedding but I got to dance at your Bar Mitzvah . . . so that's good enough for me."

And years later, you have accepted my life partner Marc into our family and treat him as your own. The cards you send to us addressed "To my SONS" pretty much say everything there is to say about you.

Mom, I'm not just proud of the mother you are to me, but the mother you are to so many. As a teacher for over 60 years, you have impacted thousands of lives given that you are still teaching today at 84 years young. The fact that kids you taught in kindergarten contact you years later to invite you to their college graduations truly reinforces how you have touched lives.

I saw the way you dealt with Dad's death after 48 amazing years as his beloved wife, and I stand in awe of you. I know losing Dad was beyond devastating. You honored Dad by living your life, staying active, and being there for your kids and grandkids. And

to see you find love again in your 80s . . . Wow!!! Talk about an inspiration.

I cannot celebrate you without talking about how funny you are. Having a Depression-era mom is not always easy. Getting you to spend money is like a hostage negotiation. Sometimes, us kids need to tell a white lie about the price of something or we know you won't enjoy it. The day you wanted to ask the postman if you could cut out the "postage not necessary" part of a government-issued envelope and reuse it on another envelope pretty much told me, "Houston, we have a problem!"

> *Mom, I'm not just proud of the mother you are to me, but the mother you are to so many.*

Even as a grown man, to this day I introduce you to my friends and people I work for and what do you say? "I'm his mom, and if he gives you a hard time, you just call me and I'll set him straight for you!"

I thank the heavens every day that you are my mom. It is a common occurrence that when people meet you, they say, "Will you be my mom too?!" Not only do you light up a room, but you exude kindness and warmth to all you meet. Quite simply, you have a special gift of making everyone feel loved and valued.

So Mom, I am thankful every day to be your son. I am the man I am today because of you, and I will always be grateful that God assigned me to be your "Little Pisher."

Love,
Michael

MONICA LEWINSKY
Marcia Straus

Dearest Mom:

If it weren't for you, I wouldn't *still* be here.

It's true.

Without your love and support during the maelstrom of 1998, I don't think I would have made it through the Starr investigation and the long shadow of the debilitating aftermath. To be sure, survival those first few weeks—drowning in a sea of fear, humiliation, and devastation—would have been unimaginable had you

not tended to me as only a mother could—as only *you* could. Other family and friends have cocooned me during some of the darker times in my life, but you have always been my beacon of hope with your trademark slogan: "Tomorrow will be better; you'll see!"

Yes it sounds trite to say that you have taught me much and shaped the woman I have become. But I can't escape the truth: In watching you engaged in meaningful conversations with almost everyone you meet, I have learned that a vibrant curiosity is a gateway to uncovering each person's uniqueness. I have come to understand that it's our connections to others that make our lives rich.

I know what it means to be cherished—just by observing the way your face lights up every time I see you. (And when you see both of your children together, let's just say "kvellfest" is what comes to mind.)

Your tireless, unending devotion to family illuminated for me the essence of loyalty, of what it means to belong.

From the art of Matisse, to the music of Leonard Cohen, to the etiquette of Emily Post, your value of culture and tradition has ensured that I have developed into a well-rounded individual. (And your love of "a little something sweet" has meant that at times I've been merely more rounded.)

> *I know what it means to be cherished—just by the way your face lights up every time I see you.*

Through your love of books, you have encouraged me to discover new worlds, new words, and new ways to feed my soul.

And perhaps most precious of all: from my earliest days you have instilled in me a respect for the gift of gratitude.

Today, I couldn't be more grateful that you are my Mom.

I love you.

"Monka"

P.S. Thanks for the hair. (No offense, Dad!)

LISA LING
Mary Mei-yan

Dear Mom,

When I was a little girl, I remember walking down the street with you in Hawaii when a young man walking in the opposite direction bumped into a telephone post because he was staring at you. It wasn't the first time that I'd seen someone smitten by you get derailed from what they were doing. You were and always have been the most beautiful woman in the world to me, but not because of what you look like. I love and am so grateful for your heart.

Like most mothers and daughters, we've had our "moments." But there is no one that I trust, and appreciate, more than you. You are always the first person that I call in times of need but also in times of triumph. Hearing your calming voice on the other end of the phone or having you hold me, whenever I've had a bad breakup, been rejected, gotten in a fight or any adverse event, never ceases to comfort me. There truly is nothing like a mother's touch.

Thank you for holding my hand when I've needed it. Thank you for boosting my confidence during low periods. Thank you for never being too busy for me. Thank you for being my best friend.

I love you, Mama,
Lisa

71

Dear Mom,

I know that dealing with a sick daughter isn't always easy. But honestly if I was to have anyone go through this and be my support system, I'm so glad it's you. You have managed to keep positive throughout all of my ups and downs, good days and terrible days. And I know how it must have killed you being so far

away when everything happened, but it all happened so fast. I was healthy, then the next day, I wasn't. Nobody could have predicted that my kidneys were shutting down, which is probably why it was so scary to deal with. But if there was a reason I was so positive, it's most definitely because I watched how you handled everything. When the doctors said I needed to start looking for a donor you raised your hand without hesitation. When our surgery day came, you were so excited. Your face was just glowing with excitement as you were preparing to save my life, to give me my life back. I will never forget when they wheeled you off to your operating room and they stopped right in front of my pre-op room and we just looked at each other, said I love you, and cried. One of the most touching moments of my life. I cannot thank you enough for what you have done for me. We are forever bonded, and I know we were before, but now it's like we are even closer, and I wouldn't trade our relationship for the world. I love you, Mom.

Forever and always,
Mikki

RUTH LOFGREN

Margaret Mages

Dear Mom,

You would have been 100 years old this year. I know you thought that 92 years were enough, but I was hoping for 100.

You had that same acceptance of whatever life handed you, whether it was a joy or an obstacle. The birth of a child, their graduations, and blooming gladiolas were balanced with a miscarriage, a child's broken arm, and a corn crop failure. That is only one of the qualities I have learned to admire in you. Of course, I didn't appreciate those qualities while I was growing up, but they have been revealed to me over the years.

Today, we all fuss about how fast and furious life is; we want to know how to "do it all." Long before that was a consideration, you *were* doing it all. As a farmer's wife with eight children, you had no choice. As a young homemaker, you lived in a house without indoor plumbing and barely an electric appliance and not only made sure we were all satisfied, but also helped with the dairy and chickens, planted and harvested a garden that fed the family all year, patched clothing and stretched every dollar. You monitored our homework and 4-H projects and made sure we made it to every choir practice. You did all that and still set an example as a woman of deep faith in God.

I am pretty sure that faith helped make you so strong. If you told us children what you expected and gave us advice, it certainly was only because you had done so and knew that we could too.

You never had to be harsh with us, you rarely raised your voice. Your example and spirit told us everything we needed to know. A good-bye hug from you was not just a gesture, it was a firm embrace that kept us safe.

[*A good-bye hug from you was not just a gesture, it was a firm embrace that kept us safe.*]

You loved to eat ice cream, drink coffee, play cards, skim the thick cream from fresh whole milk and put it on your breakfast cereal, bake with rhubarb, make kolaches, and watch *Judge Judy* when you couldn't sleep at night. Your pickles and potato salad are legendary beyond our family.

Of course, I have heard that we turn into our mothers. I hope I did.

With grateful love,
Ruth

PETER MacQUARRIE
Belva MacQuarrie

Dear Mom,

When I was a little boy, you taught me to share with people. You told me it is good to share with others, and that I would be rewarded. At that time, I didn't understand your wisdom and generosity. I looked up at you with a sour look on my little face, and I told you, "They don't share with me."

Despite my immaturity and selfishness, you were a loving mother and said, "Peter, share with those who do not share with you. One day, you will be rewarded."

I did as you said, sharing my M&M's and toys with my little friends. Seldom did they return my generosity. But, I continued on with a giving heart. For the most part, they just took and did not give in return. I never understood why they weren't like you, Mom.

I am a grown man now, and I remember your words to this day. My heart has grown and I'm a caring, loving person like you. I thank you for teaching me right from wrong. I can see how I would be like those who don't share, and how they don't know the joy of giving to others. Over the past ten years, I have helped over 1,500 homeless people, and I tell them, "My mother taught me to share."

My reward is a mother who loved me for me and not because I earned it.

Because of you, Mom, I loved those who don't know what it means to love in return. It is a great feeling to know I am a good person, and being able to hold my head up high is a wonderful thing.

I know you are gone now, and you are away, but if you were here today, you would tell me, "Job well done, my son."

Love,
Peter

Dear Mom,

You always have things planned out like the time my betta fish died. You got me a new one a couple days after. When I have a bad day you are always there to help me. You have been there my whole life. Thank you for having steaming chocolate chip banana bread ready for dessert. You're the best!

Love,
Carolyn, age 8

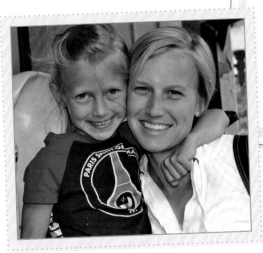

Dear Mom,

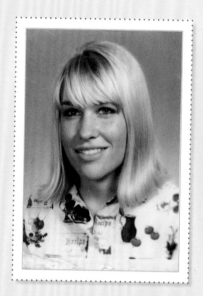

WOW. Now that I am a mother myself, I have so much more appreciation, admiration, and respect for you as a single mom than I ever thought possible.

I really don't know how you did it. As a fairly new mother, I find myself so overwhelmed at times with my one little guy—to think you had three! As I struggle to maintain my sanity through the "terrible twos," you did it three times. As I struggle to change my thousandth diaper blowout without throwing up, you did it three thousand times. As I struggle through dinnertime and bedtime on nights I am exhausted, you did it every night for three children. When I am so dog-tired I cannot muster the strength to do anything, my husband steps in; you didn't have that luxury, you found the strength.

When the days were long and tiring, you still smiled through bathtime and bedtime. When the money was tight, you still made sure your children didn't go to sleep on an empty stomach. All alone you worked tirelessly to provide the very best you could for your children.

Every Mother's Day I think of you, and wonder what it must have been like every Mother's Day alone with three young children. When so many mothers were getting breakfast in bed, you were serving it. When so many mothers were being showered with gifts, you were providing for your children.

77

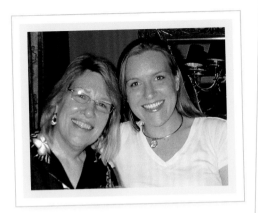
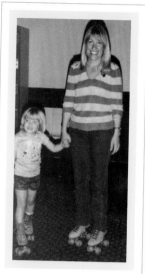

I wonder if you knew back then just how much it would mean to your children now. I wonder if you knew your unconditional love and strength would finally be noticed and appreciated.

> *I wonder if you knew your unconditional love and strength would finally be noticed and appreciated.*

Mom, thank you. Thank you for holding me all of those nights I was sick or crying over a heartbreak. Thank you, Mom, for standing by me when I made poor decisions and let you down. Thank you, Mom, for teaching me about unconditional love and tough love. Thank you, Mom, for being the most amazing woman I know.

I love you.

April

DR. PHIL McGRAW
Geraldine "Jerrie" McGraw

Hey Grandma,

You and I have always had one of those "unspoken bonds." We understood each other from the start, but that is no excuse for my not actually telling you how I feel. So I am writing to share a few thoughts that I don't say *out loud* often enough.

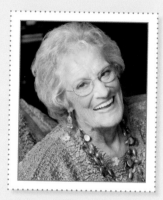

The "footprint" of your willing spirit and loving heart are more deeply etched into us than Jay and Jordan's baby handprints were in the concrete sidewalk in front of our Texas home. Robin and I marvel at how your kindness, courage, strength, optimism, and rock-solid values have found their way into our whole family right down through our grandchildren. I can't remember a time when I, along with everyone else who knew you, didn't call you "Grandma!"

You have never been one to love from afar or just with words. "No" simply wasn't in your vocabulary when it came to family.

The examples that come to mind may seem unremarkable, but your impact never was. When the boys were little, you never missed even a haircut or the chance to go along when Robin bought them a new pair of shoes. Between their adoring mother and devoted grandmother, those boys "had it made!"

Love like yours has such a "ripple effect" because your tenderness and wisdom have been passed along to the next generation of McGraws. Just last week, you were helpful to Jay as he comforted little Avery before starting preschool. Jay assured her that other people besides Mom and Dad were "okay"; he knew that because you made him feel safe and loved every day of his life. You expanded his world to trust others in a meaningful way—a

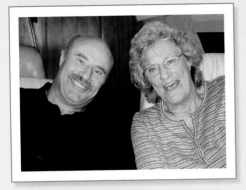

lesson he shared with Avery when she needed it most.

When 2-year-old London, his feelings hurt, came running into the house in tears the other day, once again you were there modeling patience and love. Jay scooped up his boy, and gently held him until they found something silly to laugh about . . . just as you always did when I was a pouty little boy who hid every time my feelings got hurt.

And it was great to have you be part of Jordan's sold-out rock concert in LA last month. Imagine seeing you in that crowd! Right before he walked onstage, you reminded Jordan, who's almost as shy as you and me, how truly talented and special he is. You told him that he had exactly what it took to make the packed house go wild—he did not disappoint.

In my entire life, there was never a single day that my dad told me he was proud of me and not a single day that you didn't tell me. People do live what they learn. From you I learned how to be a compassionate, engaged, loving husband, father, and man; even at my age, I still do my best to not disappoint you. Not that I ever really could. People often joked that I could set the house on fire and you'd jump in to say, "Oh, he probably just needs a nap. It's OK!" You always had my back. You have written on the slate of who I am every day of my life. I knew that as long as you were in this world, I always had at least one admirer who thought I was the best and smartest person on earth.

You gave so much to others, but I know that life was not always easy for you.

You never talked about it, but I knew that you had to drop out of school to start working in the cotton fields and do other jobs in your small town. It seemed just when things would level out tragedy would strike. You were crushed when my father and your husband died an untimely death after years of alcoholism and poor

health. But like always, you bounced back and found peace and happiness with a "new normal." You always made me know that we would be OK and not with magical thinking or waiting for miracles. Instead, you said that *I* would "find a way to find a way." Because *you* believed that I would succeed, I began to believe it too.

> *I knew that as long as you were in this world, I always had at least one admirer who thought I was the best and smartest person on earth.*

Tragedy knocked again. I will never forget the day you were diagnosed with terminal cancer. It was the most difficult day of my adult life. You had been through so much pain and heartache—how could the monster that was lung cancer come to you? The doctors said, "Ninety days tops." You said, "They have their schedule, I have mine!" The fight was on! Five years later: cancer free! Ten years later: cancer free! Grace under fire.

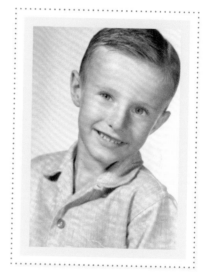

Physically, you left us three years ago. Ultimately it was your heart that gave out—the biggest heart that ever beat.

I miss you like crazy, but as I said earlier, you are still here. Your spirit permeates every one of us in ways large and small. We sure are living what we learned—I couldn't have asked for a better teacher. Thanks, Grandma, I love you.

Your Favorite Son,
Phil

Dear Mom,

When I got the call you were being taken to the hospital with a suspected brain aneurysm, the methodical part of my brain

scrambled for the fastest way to get to you, while the panicked part of my heart worried I was losing *the most important woman* in my life.

Once at the hospital, I held the hands that made my clothes to the light of the sewing machine so many nights. But I wondered how many *more* hours of rest you lost weaving a tapestry of worry for me over the years.

At your bedside, I kissed knuckles that seemed worked to the bone when you were a factory manager guiding entire buildings of seamstresses. You were my shining example of a strong female leader in an era when none of my friends had a mom in management.

Though your grip was weak that night in the hospital, your hands demonstrated an *incredible work ethic*. From hours of overtime to daily meal prep, you selflessly toiled for what must have seemed like an ungrateful brood.

As you lay there, I marveled at you, a fascinating study in contrasts.

Your naughty, self-deprecating humor belies your stringent code of treating everyone with respect.

You rarely cry. Yet your soft heart is evidenced in the patina of your bakeware, worn by years of casseroles for the sick or grieving.

You're not a makeup queen. But you said "You could do that!" watching a TV pageant during my tomboy phase. I credit you,

Mom, with planting that seed of confidence and watering it with a can-do spirit.

In the initial days of your health scare, we worried your speech might be affected. Hard to imagine not getting to hear your frank advice: "Learn to deal with assholes. Because there will *always* be an asshole."

"If you don't win/aren't chosen/don't get the job . . . I'll always think you *should* have!"

With similar to-the-point style, you delivered my first indication that things were improving quickly.

"I want to wake up in my hospital bed and see YOU on my TV tomorrow."

Message received: The unexplained bleeding in your skull would NOT be taking our mother! Not now.

Not ever, I wish.

Mom, I recognize we all eventually cross that bridge. Just know: The day I can no longer tell you "I love you bunches!" is the moment our lives develop a huge void. There is simply no substitute for your presence, vitality, and love without end.

As my mom, you'll always be *a part* of me. THE BEST PART.

Love you bunches,
Robin

Dear Mom,

You were killed in a fire two days after Christmas. I'm only telling you because I'm hoping you don't remember any of it. Something smoldered long enough to fill your house with smoke and awaken you.

What we know for sure is that you opened the back door to let the dogs out, though only Quinn, the chow, made it. Lilly, your darling lab, was found on the bed. The smoke got to her too fast.

It got to you, too. The fumes made you brave (or stupid) enough to think that you alone could put out the fire. You filled a pot with water in the kitchen and took it to the living room. We only know this because we got the 911 call, and we heard, through heaving coughs and tears, how you tried to explain what you were doing. The call lasted just under three minutes before something called a "changeover" occurred. Don't worry, they had to explain it to me, too. It's when smoke gets so hot that it bursts into a fiery explosion. You were killed instantly. Thankfully.

Until then, it was a good Christmas. Remember? We all surprised you in Seattle, hiding in Rachel's kitchen until you walked in the door and almost died of shock to see your three daughters in one place. I wish you had died of shock.

"You've got to be shitting me!" you

exclaimed when you saw us. You loved that expression. I always thought that kind of language was a little low-rent for a woman who graduated magna cum laude with a degree in fine art, but I tried not to judge you.

You were, and still are, the smartest person I've ever known. And the most beautiful. And the kindest. Life was not always kind to you, though. You lost your mom young, too. Your dad wasn't really around. Being a single mom and an artist meant for very lean times growing up, but you always had an abundance of love, laughter, and wit to share.

I was the last one of us to see you alive. I hugged you good-bye on Rachel's porch and watched you drive away. You lived just down the road, but it wasn't until the next morning, when we went to pick you up to go the gym to work off our holiday feasting, that we even knew of the fire.

Camera crews swarmed as we flew out of the car and up to the house. We were instantly encircled by firemen, so when the fire chief told us you were still inside the charred house our reaction wouldn't be revealed on the morning news.

Hours later, after they removed your body, they let us in—and on our hands and knees, through wet soot and ashes, we got that house emptied of every rescued possession. Sadly, most of your art was destroyed.

We went through your bedroom last. Clothes that once hung in your closet left soot imprints on the wall. It looked like one of your charcoal sketches. Deep in the back of that closet, I found a suitcase. You know the one. It was, astonishingly, unscathed. I opened it to find all of your diaries, love letters, divorce papers, and other scraps that meant something to you at one time or another in life. Though we put most of your things into storage,

I kept your diaries and took them back with me to LA. I hope you don't mind.

What I read, which wasn't really news to me, was that you never felt loved enough. Not from your dad, not from my dad, and certainly not from the any of those boyfriends of yours. Your capacity to love was cosmic—you loved deeper and cared more than anyone I know. You would take in anyone that needed help— human or animal. You would give your last dollar to someone in need, even if you needed it more. You called yourself a magnet for weirdos. I think you were just a bright light in their darkness.

You loved people in the way you wanted to be loved—epically, unconditionally, and forever and ever.

> *Your capacity to love was cosmic—you loved deeper and cared more than anyone I know.*

Sadly, you never got that epic love that you so greatly deserved. That's not to say you weren't loved. People loved you—but just not the right ones and not enough. I loved you so much. I always wished I was enough, but I understand, now that I'm married to someone who loves me the way I need to be loved, that love comes in different forms.

So thank you, Mom, for showing me the many ways to love a person and just how big a heart can be. And though yours stopped violently short, your memory and love beats in mine every day.

All My Love,
Sarah

*Hello there,
my beautiful Mama,*

I miss you more than words can ever describe. A day doesn't go by without my thinking of you. When people ask me about you and what you were like, I say if you could take all the incredible qualities a mother should have, all the beautiful things a mother should do, all the expected things a mom should be, that would describe my mom exactly. And I thank God every day for giving me you.

It's funny because oftentimes, I still think I'll just pick up the phone and "call Mom about that" as I used to do almost daily, but then I realize I can't actually do that. But here's the thing, Mom; you ARE still here, all around, in everything I do.

Mom, you taught me to love and to love big-time. That's what you were all about! Not a day went by without my having that sense of security which every child deserves—knowing that you are loved, beyond a doubt, by your parents.

You would say "I love you!" to me multiple times a day. There was never a night we said good night without making sure those were the last three words spoken before we fell asleep. And I so hope that I give my kids that same gift of feeling beyond loved that I was given. Sometimes, I say "I love you" so many times that Ashby will say, "Really, you've already told me that like 100 times today!" I chuckle to myself because I know when she is older, she will get it.

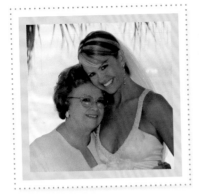

Mom, you were always there for me. You never missed a single tennis tournament, basketball match, cheerleading competition, piano recital, or school trip. I can picture you in the stands now with a thermos full of orange juice and peanut butter crackers, just in case I needed energy.

Mom, you were my best friend. I could talk to you about anything. And you always knew just the right thing to say and what I needed to hear. I'll never forget how traumatized I was thinking about going away to college. Most kids are ready to get away from their parents as quickly as they can when it comes college time, but for me, just the thought of not being around my best friend every day made me sad.

Mom, you gave me confidence. Whenever I was scared, you gave me strength. You made me feel like no matter what I did, you would be proud.

> *Mom, you gave me confidence. Whenever I was scared, you gave me strength.*

And now, whenever I get anxious about something, I hear you and a peacefulness comes over me.

Mom, you made me feel safe. You had that Mama Bear in you and I knew, growing up, that you would go to whatever lengths you needed to in order to protect your children. I will never forget one incident during that last year of your life. Ashby was probably six months old and she coughed, as if she had something caught in her throat. I saw that Grandma Bear jump into action. ALS had taken nearly all of your muscle strength, but despite that you lunged over to her and swept your finger through her mouth to

make sure she wasn't choking. Your will to protect your children and grandchildren was stronger than everything!

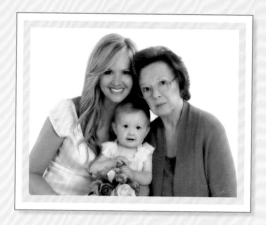

You taught me to be friends with everyone, to treat everybody equally, and not to judge because "that hurts people and if you hurt people, it hurts you even more." You didn't have a mean bone in your body, Mom, and you wanted to make everyone feel special. Remember how you used to make cookies for all of my childhood friends? But it wasn't just one batch of cookies. Nope, you had to make every child his or her favorite kind.

Mom, you taught me what a marriage is supposed to be like. I love the relationship you and Dad had. You were his partner, his best friend. I saw how you treated each other, with respect and kindness. Because of that, I know how to be a good and loving wife to Keith.

You were right, Mom, all people are beautiful and your beauty was immense. To me, you were the most beautiful woman in the world . . . an angel. Ashby and I say hello to our angel every day when we pass by your picture in the hall. Ashby tells me often how she wishes Grandma Betty were here. I tell her you are, just like an angel; we can feel your guidance and your love as you walk though life beside us. Even though you passed away just shy of Ashby turning a year old, she knows you. I tell her all about you, how much you loved her, and what a wonderful grandmother and mother you were. But I hope she gets to know you best by my being the kind of mother you were.

So, thank you, my angel.

Good night, Mom. I love you!
Nancy

Dear Mom,

It's been one and a half years now since you have passed. Some would say that is a short period of time, but for me it has been long enough to think about all the things that I wish we could have worked out between the two of us before you left for good.

When I was younger I knew without a shadow of a doubt how much we loved each other. I could feel it! We would say it! We would show it! I always felt like I was your protector and had this fantasy that the two of us one day would run away and everything would be great forever. I remember so vividly that when you and Daddy would go out on a date I would sit on the arm of the living room chair waiting for you to return. I would watch all the cars' headlights coming down our street; I would not move until you turned into our driveway. You had to come back to me.

So I have to ask, what happened between us? Why in your last years were you not able to tell me you loved me? Why, Mom? I know you knew how much I wanted to hear those words. They really were the only words I wanted to hear. What did I do to make you want to punish me so much and not give me the one thing I wanted from you? Four little, but massively powerful words: *"Suze, I love you."*

I know from our family and friends you would tell them how much you loved me, but you could not say it to me. Your silence carved a hole in my heart.

Aunty Thelma sat me down after your passing and told me that you did love me, but the one thing you could never accept about me was the fact that I was gay. Really? Is that possible? Mom, I told you that being gay was the best thing that ever happened

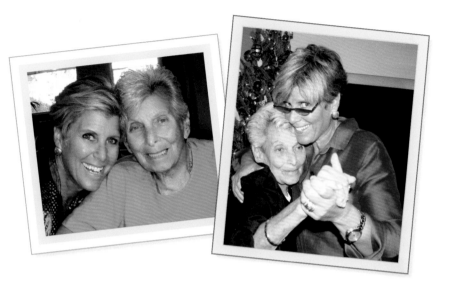

to me in my entire life. I understood why you were so upset with some of the relationships I had, for they did not demonstrate self-respect on my part. But my life started to soar around my 50th birthday when the greatest gift of my life, "KT," presented herself to me. You loved KT. Do you remember the three of us going out to dinner when you told us that now you could go to your grave a happy woman for KT was in my life?

All was so good, but then what happened? Was it simply that as you were getting closer to death you decided to live in other times in your head and forgot how happy I was in the present?

Was it simply that when your mind started to slip that the smiles on my face and in my heart slipped with it? I guess the plain truth is I will never ever know for sure.

> *Money will come and go, success will come and go, my fame will come and go, but one thing that can never be taken from me no matter what is the love I have in my heart.*

But, Mom, just in case this makes its way to you, please know that out of all my accomplishments and successes that you were able to witness and brag to your friends about, that the great success of my entire life is that I know my own thoughts. I know

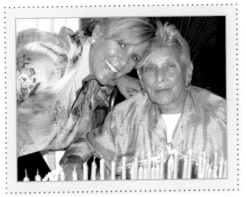

who I am and whom I love. Money will come and go, success will come and go, my fame will come and go, but one thing that can never be taken from me no matter what is the love I have in my heart. My heart is a full heart and one that greets everyday with a smile. I have known love in a way that most will never know. I have had the great good fortune to have a woman in my life that is 100% pure goodness. And with KT comes KT's family; they have embraced me and taught me what it really means to be a true family.

So, Mom, regardless of what Aunty told me—who by the way is up there looking for you now if you have not already found each other—with the writing of this letter I have chosen to believe that you did love me, you do love me, and that my faith in that truth is more important than any words you could have said.

I miss you, MOM, and it feels good to miss you, but I am happy you finally went home to Dad, to your mom Goldie, to many of your friends, and to me in your own special way. One day maybe we will meet up in the great forever but until then know I love you and thank you for loving me.

Your birthday is one month away. I know how much you loved your birthday. Happy 99th, Mom!

I love you.
Suze

KELLY OSBOURNE
Sharon Osbourne

Dear Mumma,

I don't know how or where to begin so I will start by saying thank you. Thank you for always being here for me. Thank you for all the sacrifices you have made in order for me to have a better life. Thank you for never giving up on me when I blamed you for everything I was doing wrong. Thank you for teaching me what love is and guiding me to become the person I am today. I am the person I am today because of you. You have taught me everything from how to brush my teeth to staying true to my beliefs no matter what people say. The only thing you never taught me was how to cook! (I really am grateful that YOU never taught me because I probably would have poisoned someone by now.) Everything I know about life is because of you.

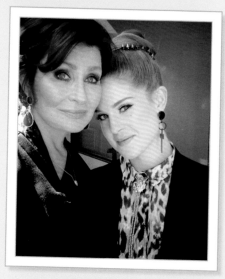

I have waited too long to tell you what you deserve to know. As a teen and up into my mid-twenties, I did everything I possibly could to make myself different, not only to my own detriment but to yours as well. I know I have already apologized and grown up a lot so you might be wondering why I am bringing this up. Like all teenage girls I had this ridiculous fear of growing up and becoming just like you. I was so ignorant and adamant about creating my "own" identity. I woke up one day and realized that I am you. How

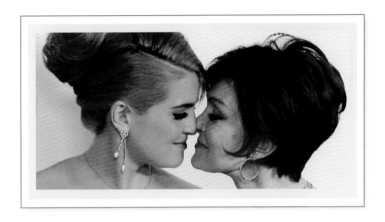

could I not be? Why had I been fighting the inevitable for so long? You are the most beautiful, kind, generous, loving, and—let's not forget—strongest person I have ever met and the best part is that you are MY mum. I am so proud to be your daughter. I love you more than words can describe. Just like I never left your side when you were sick, I will never stop loving you more and more with every day that passes. I could not live without you—you truly are the best!

> *You are the most beautiful, kind, generous, loving, and—let's not forget—strongest person I have ever met and the best part is that you are MY mum.*

I love you I love you I love you.

Kelly
X

P.S. You are still bloody nuts and at times drive me insane . . . but I would not have you any other way. To me you are perfect!!!

TEJAL PATEL
Kokila Patel

Dear Mom,

To the most challenging, heart-opening, and unconditionally loving relationship in my life.

Our relationship has been far from easy, but scanning back on the last 31 years of my life, I can't believe how our tumultuous and painful journey has transformed to one of respect, acceptance, and peace. It seems like a dream that only 3 years ago, I was purging 28 years of repressed pain and resentment from feeling like a victim of your anger and emotional unavailability.

They say the most challenging relationships are our greatest blessings because they teach us the most. Without you even consciously trying, you have been one of my greatest spiritual teachers. Each time I was triggered by your words and anger, it was an opportunity for me to take responsibility for my part in our relationship discord. I was forced to face my shadow sides, work on releasing my ego, and heal my wounded heart. I am stronger, more forgiving, and compassionate because of the challenges in our relationship. Even if I could, I would never change the past. If it weren't for those 28 years of pain, I wouldn't have felt the urgency to awaken so early in my life. I was taken out of my comfort zone to evolve by learning my spiritual lessons.

For the first time, I recognize our true identities. We are not women, we are not our mother and daughter roles, we are not our ego personalities, we are not people, we are souls—we are divine beings of infinite love and pure radiant light.

Thank you for helping me learn that parenting mistakes don't have to be traumatic battle scars; they are stepping-stones to evolve into a better person, a better parent, and a greater spiritual being.

Thank you for teaching me unconditional love isn't defined by the words you say, but by your presence, by your embrace, and by the simple actions you do like wholeheartedly cooking meals for your family.

[
They say the most challenging relationships are our greatest blessings because they teach us the most.
]

I honor you for giving me the greatest gift one could ever bestow on another, the precious gift of life. You nurtured me when I was a helpless child and you supported me as I flourished into a free-spirited woman.

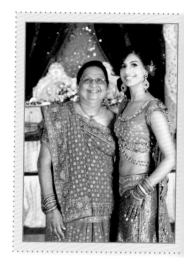

To the radiant soul I am grateful to have chosen to be my mother, may the light in me always honor the light within you. May we always be bound together in peace, love, and respect. And may the love of our souls be connected in this lifetime and beyond.

As I finish with tears in my eyes, I set the intention that I too may be blessed with the gift of a daughter, so I may touch her soul as you have deeply touched mine.

With Love Always,
Your Teju Beta

Mom,

You are unlike anyone I have ever met. You are the most caring, kind, bright, strong, and loving person I know and I am so glad that you, my superhero, are my mom!

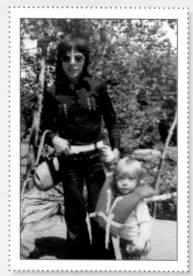

My first memory is of being enveloped in your selfless love. I remember your hugs being some of the greatest moments in my life, from childhood until now, "warm fuzzies." Your hugs have given me courage, celebrated my smallest and greatest feats, calmed my nerves, taken away my fears, healed my pain, and made me know that I was loved more than anything in the world! I am so proud to wear my heart on my sleeve, and I do so because you taught me that it is okay to care for others as much as you care for yourself.

Mom, I have lived every moment of my life in your reflection, trying to be as extraordinary as you are. In every moment I was afraid or had doubt or fear, I would think, "what would Mom do?" In every moment of awe, great happiness, success, or accomplishment, or even when something just made me laugh, I couldn't wait to share it with you.

You have been my greatest role model, my one and only true muse, my best friend, my confidante, and always, always my greatest supporter.

I thank you from the bottom of my heart for all the great sacrifices you made to give me, Dad, Chris, and Jon the best life possible.

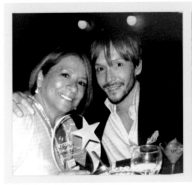
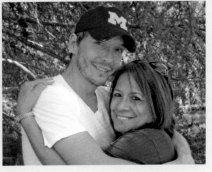

I always love bragging that not only did you raise three (rowdy) boys, four if you include Dad, but you also worked all along the way: cleaning houses, planting at a nursery, working in a machine shop, and any other way you could help contribute to a better life for your family. While Dad was working seven days a week, you did everything . . . from taking me to my first day of school while I was clinging to your leg, and getting a job there so I would stay, to coaching my baseball team. You taught me to dance, well, "boogie down," and how to rebuild my first car from the frame up. You and Dad ran (and still do) my first salon in Detroit, to great success, while allowing me to travel to pursue my dreams!

When I envision all of our great memories, you are usually wearing your sky blue, "small but mighty" metallic rainbow-colored T-shirt, and yes, Mom, you are small but mighty and so much more: you are truly my greatest superhero.

As I think of you, know that I am smiling from ear to ear, my heart is full, I can feel your "warm fuzzie" hug, and I know that I can do anything I want in this world and accomplish my greatest dreams because you, Mom, made it so!! Thank you! I only hope that I have lived a life that makes you proud so that you can see that all your love and hard work have paid off. I promise to always live to make you proud.

Mommy and I are one!

Love,
Presh!!!

MARTIN PAVES
Susan Kathy Ford

My Dearest Mommy,

I don't even know where to begin. You have been so incredibly loving, gentle, patient, loyal, funny, and a wonderful mother to me.

I can still remember the first day you took me to daycare. I wrapped my tiny arms around your legs, held on for dear life, and refused to let go. You gently sat me down and, with your infectious smile, told me it was "OK"; you told me how much you loved me, how much fun I would have. You promised to be back real soon, tickled my chubby little tummy with your porcelain hands, smiled, told me you loved me again, and I giggled and walked in as a big boy. I knew then that you would always be there, whenever I needed you most.

You taught me that being deaf was my actual strength and made me so proud to come from a third-generation deaf family. You encouraged me to see the world differently and gave me confidence to share our beautiful language, American Sign Language. I appreciate that you tried to guide and encourage me with such care, and always your smile! I am so happy that I have your heart; you did everything with love and patience.

I carry *you* with me every day; everything you have taught me has made me who I am today. The things I like the most about *me* are the things I inherited and learned from *you*. At times, I laugh and think that I am just like you, your twin!

I hope my life is just as you saw it the first moment I was laid in your arms. I am so proud to share this letter with the world, dedicated to you, and express my love and respect for you, and recognize you for the wonderful mother you are! My dearest Mommy, you are the true definition of what "Mother" means to me!

Your loving son,
Martin

Dear Mom,

It is hard to imagine I lost you so long ago. I was just 15, and you were only 40. Now, I am nearly the age you were when God suddenly took you from us. I can't help but know you had so much work left to do.

I will always remember you as a young, beautiful, vibrant woman. Your spirit always radiated light, beauty, and love even as you grew ill. As a young mom, we grew very close. You were my best friend. You still are. You taught me what it means to be a good friend, to be fiercely loyal, giving, and loving.

Growing up, you taught me how to be a "little lady," playing dress-up, instilling good manners and values, and having tea parties (of course :)). You inspired my creativity in all things, especially encouraging my writing. You celebrated me when I was first published in the local paper as a child, and I know you would be proud of the career I have made for myself in journalism.

I miss your face, your smile, and your voice every single day, Mom. I keep my favorite photos of you around me always. The ones I cherish most are the "before" photos. Before you got sick, and before the illness dimmed so much of your sparkle. I try to live my life in honor of how you would, had you had the opportunity to be here to do it. I live with integrity, and love strongly. I laugh

loudly and sometimes so hard that my belly hurts. I don't take myself too seriously. I admit when I am wrong, stubbornly though. I am not even close to perfect, but I try to live beautifully as I perceived you always did.

It took me a while to learn that even though you are not physically here anymore, your beautiful spirit is and has always been with me. I find your comforting warmth in all the wonderful beings and experiences that fill my heart with so much joy. I see you in the aura of all my dearest, closest friends. All of whom I know you've personally sent to fill me with the love you are continuing to give me. I felt your strong spirit in all of my incredible bosses that believed in me, challenged me, and lifted me up in my career. I carried you with me as I crossed the finish line at the one and only marathon I've ever run. I know you would be impressed by the darling and handsome man I've chosen as my husband. You were with me on my wedding day in the hand-beaded pearls on my dress that we used from your wedding gown. You were with me when I gave birth to my little girl; I wore your wedding band in the delivery room. I see you in all things beautiful—rainbows, pristine snow on the mountains that we love to ski on—and in the peaceful spring and summer breezes I can sometimes hear you whispering that you love me and miss me too.

I know that you would love our family today. You would be proud of all of your children, each of us grieving differently in the loss of you but searching tirelessly for traces of "you" in our day-to-day lives, and Dad, for picking up the pieces after we lost you and finding happiness. The woman Dad has chosen is a wonderful, smart, tough woman who has been there for us, during the incredibly difficult time when we all challenged her in dealing with our own grief, and we have each formed lovely personal connections with her as our mom too. She will never replace you, but she is a lovely complement to all that you are to us as a mom.

We have enough space in our hearts, and are lucky enough to have two.

> *I try to live my life in honor of how you would, had you had the opportunity to be here to do it.*

Thank you, Mom, for all the beauty of "YOU" that you have sent to me. Now that I am wise enough to recognize you in all these magical ways I can hear your voice when I close my eyes tight. I can feel your comfort in the arms of all my beloved family and dear friends. Now when I miss your face, or your smile . . . all I have to do is look deeply into the sparkly, beautiful blue eyes of my baby daughter. She's got your eyes, and like yours, her smile lights up a dark room. Thank you, Mom, for keeping the "light" of "YOU" in my life always.

Katie

Mom,

I received the note that you slipped under my bedroom door last night. I was very excited to read it, thinking that it would contain amazing, loving advice that you wanted to share with me. Imagine my surprise when I opened it and saw that it began with the salutation, "Dear Landlord."

I have reviewed your complaints, and addressed them below:

1. While I appreciate your desire to "upgrade" your accommodations to a larger space, I cannot, in good conscience, move Cooper to the laundry room. I do agree that it will teach him a life lesson about fluffing and folding, but since I don't foresee him having a future in dry cleaning, I must say "no."

Also, I know you are a true creative genius (and I am in awe of the depth of your instincts) but breaking down a wall without my permission is not an appropriate way to express that creativity. It is not only a boundary violation but a building code violation as well.

Additionally, the repairman can't get here until next week so your expansion plan will have to be put on hold.

2. Re: your fellow "tenant" (your word), Cooper, while I trust you with him it is not okay for you to undermine my rules. It is not okay that you let him have chips and ice cream for dinner. It is not okay that you let him skip school to go to the movies. And it's really not okay that the movie was *Last Tango in Paris.*

As for your taking his friends to a "gentlemen's club," I accepted your rationale that it was an educational experience for the boys (and you are right, he is the most popular kid in school right now), but I'd prefer he not learn biology from those "gentlemen," and their ladies, Bambi, Trixie, and Kitten, and just because I yelled at you, I do not appreciate your claim that I have created a hostile living environment.

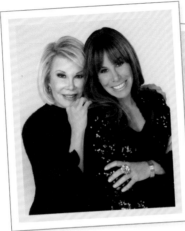
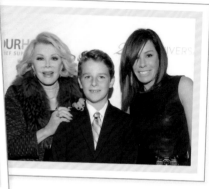

3. While I'm glad to see you're socializing, you must refill the hot tub after your parties. In fact—you need to tone down the parties altogether. Imagine my surprise when I saw the photos you posted on Facebook of your friends frolicking topless in the hot tub.

I think it's great that you're entertaining more often but I can't keep fielding complaints from the neighbors about your noisy party games, like Ring Around the Walker, or naked Duck, Duck, Caregiver.

I'm more than happy to have you use the house for social gatherings, but you cannot rent it out, advertise as "Party Central," or hand out T-shirts that say, "F*** Jimmy Buffett."

In closing, I hope I have satisfactorily answered your complaints and queries. I love having you live with me and am very grateful for every minute Cooper and I have with you. You are an inspiration. You are also thirty days late with the rent.

Much love,
Melissa

cc:
Murray Weinblatt, Atty-at-Law

John Smith, FCC

Malibu Homeowners Association

Free Clinic of West LA

Provost, Happy Valley Middle School

Don Gino Botticelli, Slickers Gentlemen's Club

SHAUN ROBINSON

Joanne Robinson

Hey Mom,

I just got off the phone with you . . . for the third time today. Thanks for walking me through how to make that yummy Jell-O salad you always take to your parties. I can't wait to let you know how it turns out!

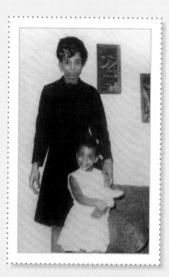

As easily as you walk me through making your signature recipes, you have walked me through so many of life's challenges. It is because of your grace, strength, faith, and guidance, that I am the woman I am today. It is also because of you that I know how to cook anything besides TV dinners.

When life has brought me lemons, you've advised me on how to make lemonade. You have been my cheerleader since the day I was born, celebrated all of my successes, and been right beside me through all of life's transitions. Thank you for being my best friend.

I look forward to our many daily conversations. It is such a blessing to hear your voice, your laugh, and yes—even your unsolicited advice. Those words, the words that only a mother will say to you, are often what I need to hear the most. Your honesty is a reflection of your love for me, and your desire for me to be my best self.

It is a blessing. These four words that you say so often hold so much power. When I have come to you while coping with heartache, after a disappointing experience, and in moments of doubt, you have said—It is a blessing.

When I have called you, concerned because you've had a cold, or a flat tire, or were simply having a bad day, you have said—It is a blessing.

"Why would you say a flat tire is a blessing?" I asked you once.

"Well, it is a blessing that I got the flat tire on a side street, and not on the freeway. Now that would have been a mess!"

What I once looked at as blind optimism, I now recognize as a manifestation of your faith, and your ability to see the good in every situation.

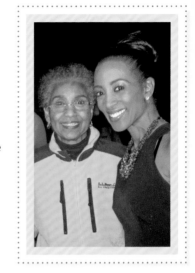

> *What I once looked at as blind optimism, I now recognize as a manifestation of your faith, and your ability to see the good in every situation.*

The most important recipe you have taught me over the years is your recipe for living a fulfilled life. It requires large amounts of patience, prayer, and perseverance, generous portions of love, forgiveness, and laughter, a dash of spice, and a pinch of zest. For teaching me this recipe—and for everything you have done over the years —thank you, thank you, thank you.

It is a blessing.

Your loving daughter,
Shaun

Dear Mom,

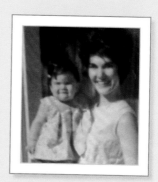

You were a baby bride at eighteen years old and a mother at twenty. You glided into the role of motherhood with happiness and enthusiasm.

I am your only child, an only daughter of an only daughter.

The years when you had to go back to work at the bank, teaching men how to do the job that was a few levels above you, you cried at leaving me. You were eager to get back to the full-time job that you loved, being my mother.

You passed on your love of books to me—the smell, the feel, and the worlds between the covers.

You made carefully packed school lunches—tiny saltine and Skippy peanut butter sandwiches, raisin cookies, and symmetrically cut carrot sticks.

You set up elaborate treasure hunts for Easter baskets and made German chocolate cakes for birthdays.

Because of your sweet panhandle Texas twang, I was the only kid in class who could spell "salmon" correctly because you always pronounced it phonetically, with the "l."

When your own father had mounting healthcare bills, you took a job in a tea factory to help with the expenses. You worked the graveyard shift so that you could still be there when I left for school in the morning and got home in the afternoon.

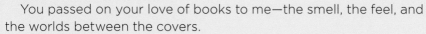
From you I learned about hard work, responsibility, and not putting elbows on the table.

You took photos of me at the front door on the first day of school, wearing something you had sewn for me.

You were the Girl Scout leader, the school cupcake mom, and the field trip driver.

That evening in November when Dad was taken from us so suddenly, you were left in the role of both father and mother.

107

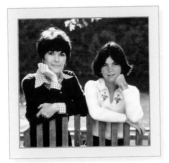

You have always kept moving forward in impossible circumstances. You sat in the audience of every recital, show, and game, applauding in the ladylike way that you taught me: holding your left hand still and clapping it with your right. You would then back it up with a loud unladylike cheer.

When I shaved half my head to be '80s fashionable, you told me that it was nice that I finally got my hair out of my face.

My friends have always loved you. I arrived home more than once to find that one of my friends had come over to hang out with you.

Your nurturing ways have always extended to strangers and the elderly. A patient and involved listener, you were a perfect companion for those whose age and circumstance had left them alone.

I called you twenty-six years ago to tell you the good news: I had thirty days of sobriety. You were proud of me.

You understand the importance of holidays and celebrating every time the opportunity presents itself.

A keeper of memories, when you made the move from your house to an apartment, you presented me with labeled bins and boxes filled with my childhood ephemera and dolls that had notes tucked in with them identifying each of their names. You have made motherhood look like the greatest joy. This is what led me to wanting to be a mother myself. When we brought our newborn son home from the hospital, you greeted us at our door. The house was clean, the laundry was done, and you had just pulled an apple pie from the oven. Now that you are a grandmother, my heart is full as I watch you with your grandson, sharing your care and curiosity of the world.

You refer to me as "your pleasure and your treasure." You are my teacher, my champion, my mentor, my mother. I love you so.

Lisa

MOLLY SIMS
Dorothy Sims

Dearest Momma,

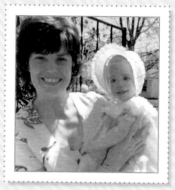

I am so lucky to have such a wonderful mom. You taught me the importance of education, showing me that I could truly be anything I wanted to be. You taught me to dream big. "Go big or go home" as we say in the South. To this day, you continue to be my champion and support system. I am incredibly blessed to have a momma like you. I still remember you with your big oversized '70s glasses and red scarf walking around the track with your weights at 6:00 in the morning! You always taught me to take care of myself. You inspire me to be a better mother, and I have often said it was you who taught me to be "graceful and grateful"—which are words that I truly live by to this day and can be applied to so many aspects of life. They have taught me humility during times of celebration, but most importantly they are the foundation by which I survive during times of difficulty. You not only taught me the words, you showed me by the way we lived our daily lives. No matter what the strife, you always managed to smile and keep your feet moving forward. How you managed to create a business with Daddy and get homemade supper on the table is beyond me. I've always seen you as a magic superhero that was always the epitome of grace. I never wanted for anything. I can't tell you how many times in my life I have called upon your strength to guide me through tough times. It is much easier to be graceful and grateful when you are receiving accolades and everything is going your way. It is much harder to be those things when the world is not being very kind and you feel backed up against the wall.

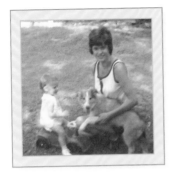

That is the precise moment you taught me to shine bright and summon all the grace and gratefulness I have to rise above the situation. Many things in life did not come easy for me. Definitely not modeling! I was actually told that I wasn't going to make it and I would never make enough money to pay back the advance of my plane ticket to Germany (my first modeling experience); you imparted the wisdom to never give up.

I have called upon your strength to guide me through tough times. It is much easier to be graceful and grateful when you are receiving accolades and everything is going your way.

For this, and all my life lessons, I will be forever thankful. My goal is to make sure I pass this way of approaching life on to Brooks. If I can be one-tenth of the momma you've been to me, then my family—my Brooksie—is lucky!! Thank you, Big Momma! You will always be the glue that holds our family together!!

xx,
Molly

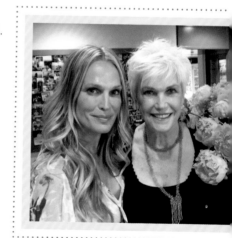

Dear Mom,

You take us fun places. You take us to school. You take us to sports. You are nice to us. You love us with all your heart. You kiss us up. You help us with our homework. You help us clean up our rooms. You help us no matter what. You are the best!

Sometimes we are not nice to you, but we still love you. You married Daddy for us to be alive, and we love him, too.

You are smart, sweet, nice, kind, loving, respectful, and polite. You taught us a lot, like math, how to spell words, how to do projects, and how to ride a bike. You get us lots of cool stuff. You tell us stories and sing us songs at night. You're nice to us when we are sad. You take care of us. You are lovable. We are so lucky to have you.

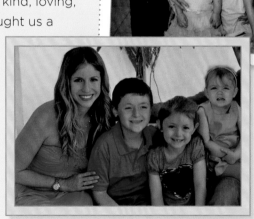

Love,
Keller, age 8
Molly, age 5
Stephanie, "Stevie," age 2
xoxoxoxoxo!

STEPHANIE SPRENGER
Chris Smith

Dear Mom,

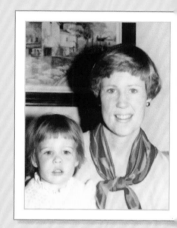

So many things have surprised me about motherhood. It is more beautiful and more rewarding than I could have ever anticipated, and the depth of love I feel for my two daughters is more ferocious than anything I have ever experienced. Of course, it's also more complicated, exhausting, and frustrating than I ever could have imagined. It's interesting how much my own motherhood has caused me to reflect on my relationship with you.

The truth is, you and I are very different mothers in many ways. You stayed home, while I go to work part-time. You volunteered, were active in the PTA, and knew everything about the inner workings of my school; I couldn't identify which kids were in my daughter's second-grade classroom if my life depended on it.

I have done a lot of things differently, and for a time I worried that I would be a disappointment in your eyes, that I could never live up to the type of mother that you were. I don't ever remember a time when you weren't there for me—I knew I could count on you for anything from an afternoon snack to a listening ear after a difficult day of school.

Even now, your capacity for selflessness and for nurturing astounds me.

I'm struck by the fact that, though seemingly *everything* has changed since I was a child, so many things have stayed the same. Not only do I still seek your approval and care deeply about your opinions, I am in awe of how much I truly *need* you still. Throughout our lives, who has the wherewithal

and devotion to spend decades supporting, consoling, and loving us besides our mothers?

Although I am acutely aware of the ways in which I have strayed from the particular brand of motherhood I experienced as a child, I also know that I have inherited so many of the important things you taught me, and I integrate those values into my own parenting. Like you, I am endlessly supportive and affectionate with my children. Like you, I am always ready to talk, listen, and help them process their frustrations as well as celebrate their beautiful, small victories. Like you, I read with them and have taught them to love both books and music. Like you, I excel at nurturing, comforting, and helping my daughters to feel cherished and safe. It's quite possible that motherhood is the first time I have loved without strings, without criticism, without *conditions*. Don't get me wrong—I have plenty of complaints about our day-to-day lives together, and gripes about the little things my girls do that drive me crazy. But this doesn't impact my love for them.

And do you know what's even more amazing? Now that I *am* a mother, having experienced this type of love, I am finally able to grasp that I *am loved unconditionally* by you. One of the most humbling aspects of motherhood is to realize that you are the object of someone's perfect love. I will be forever grateful for that.

So thank you, Mom, for setting the bar high, for teaching me how to love and give of myself, for accepting me in spite of my flaws, for celebrating our differences, and most importantly, for teaching me about unconditional love. It is the most beautiful gift you could have ever given me.

With Love and Gratitude,
Stephanie

Dear Mom,

I'm sorry.

I never wanted kids. I told you that I was fine without them.

Kids were loud, messy, inconvenient, expensive, exhausting, draining, work. How could anyone want kids?

When I became a stepmom I thought, "Whew, I'm off the hook, you finally have grandkids." Whom you embraced fully as if they were your own. You became Super Grandma! But I still wasn't convinced to have kids of my own.

I'm writing now to say *I'm sorry* . . . and *you were right*.

Kids are definitely loud. Marty and I were very loud, but we could always make you laugh. You actually encouraged us to be louder and find our voices.

We were messy but you taught us to clean up after ourselves and always start the day by making our beds. You let us build forts out of everything and keep them up for days. You painted a rainbow on my wall because I loved rainbows. And I was your sunshine.

As far as we could tell, we were not an inconvenience because you always made time for us. You went to every game, performance, and recital. You cheered the loudest and took lots of photos.

I know we were expensive because you paid for ballet, jazz, soccer, baseball, basketball, football, wrestling, skiing, modeling, uniforms, tutus, and college. Plus you made sure that Santa knew what we wanted for Christmas and you were up all night wrapping

presents and made sure the tree was full of joy. You were exhausted but you loved it. You added a touch of sparkle to every holiday.

You told me I was beautiful, capable, and you said I could do anything; you told me to never give up, try my best, reach for the stars, and work hard for what I wanted. You encouraged me to try out for Little League, even though I was the only girl. When I made the team, you were at every game and you cheered the loudest.

I know I was work because you were always checking up on me to make sure I was safe, and you made me call if I was going to be late. I did stupid stuff and dated boys that you and Dad did not approve of. But you let me ultimately decide. And I eventually found Mr. Right.

You always made time for us. Your face still lights up when we walk in the room and you always answer the phone like we haven't spoken in years. You make me feel like I am the most important person in your life.

Mom, I always knew that you really wanted grandchildren, yet you supported my decision not to have kids. (OK, maybe the suggestion that I should freeze my eggs "just in case" was just a hint . . .) Well, that approach worked . . . because I met Glenn, and I

heard a whisper deep within that I guess I hadn't heard before . . . I was finally ready to listen.

Two years into our marriage and multiple IVF procedures later, Brooke and Taylor were born.

Guess what? I now laugh deeper than I have ever laughed. My girls are loud and messy, but they make their beds every morning, they build forts everywhere, and I let them leave them up for days. They love rainbows and they are my sunshine. I attend every game, performance, and recital. I cheer the loudest and take lots of photos. On Christmas Eve, I am up all night wrapping presents, and I try to make every holiday sparkle. When they are older I will ask them to call when they are going to be late and I will try to let them make their own decisions about boys and hope for the best. I tell them they are beautiful and capable and if they work hard they can accomplish great things. When they walk in the room my face lights up. They are the most important people in my life.

> *You told me I was beautiful, capable, and you said I could do anything; you told me to never give up, try my best, reach for the stars, and work hard for what I wanted.*

So, Mom, I AM sorry and you were right. It feels so good to say that. You knew how much I would love my own children and I always knew you loved me, I just didn't realize just how much . . . until I became a mom.

I love you,
Mindy

Dear Mom,

We would be nowhere without you. You are an absolutely beautiful-spirited human and we can only hope to be just like you. You have taught us to never judge anyone, to accept everyone, and to love equally. One of the most important things that you have taught us is to "never hate." You

live by this, and thankfully instilled this in us, so we live by it as well. You are an amazing mother, who yes, can't drive to the end of the street without a GPS, and yes, you may constantly have uncontrollable laughing fits at the worst times, but that's what makes you so fantastic. You inspire everything we do in every aspect of our lives. You guide us with your whole heart, which is more than we could ever ask for. We love you more than anyone could ever comprehend. Thank you for everything.

Mom—One year ago on Maisy's birthday when we were all getting ready for the cake, you started handing the pieces out, and you gave every person in the room a slice of cake before yourself. I remember feeling such awe and I asked you why you did that. You said that it's important to always put others before yourself. From that moment on, I felt inspired and in love with the thought of putting everyone before yourself. I thought it was so generous and thoughtful. You teach me everything there is to know about pure, raw love and being a genuinely kindhearted human. I look up to you so much and in so many different ways. Remember when I said that saying the word *love* just didn't feel like enough to show how I feel about you? Well, I tried switching the letters around a little and got "ovle." Well, I ovle you, with all of my heart.
 —Lennon

117

Mom—It makes me feel so insanely loved when you are on stage, and you look for me in the crowd. I feel so special when you smile at me with the charming smile of yours, and I just think, I have the most amazing mom in the whole entire world. You are a special human, and no one could ever be as beautiful as you. This is almost how much I love you: count every star in the sky and times that by 1,000,000 and that's *almost* how much I love you. You are such an inspiration to me as a person. We have such a great connection as a mother and a daughter, and that's all I can ever ask for in my life. Thank you for always being there for me. I love you with every bit of my heart.

—Maisy

Thank you so much for being our caring, beautiful mom. You are a true angel. You are our guiding light in everything we do and we appreciate your love more than you will ever know. Forever and always, we ovle you.

Love,
Lennon, age 15
Maisy, age 11

Dear Mom,

VICTOR: Over the course of time many songs have been sung to celebrate mothers for who they are. I would like to write such a song! An ode to sing her praises to the world and to attempt to define the indefinable things that set her apart!

I would begin the verse by describing the sound of her comforting voice, a sweet familiar call that has the power to heal when you are hurting emotionally.

In the chorus I would sing about the beauty of her heart, and how it radiates love and light whenever she is in your presence.

The bridge of the song would speak of her devotion to consistently give everything she has to make her children happy, even when she has little left to give. She is the mother that exceeds what a parent should be and expects nothing in return.

CLIFTON: I count my lucky stars that I was blessed with a mother like you. You've shown me kindness, poetry, patience, true grit, faith, hope, and love. But the greatest of all these is love.

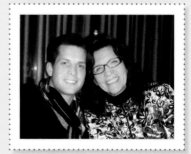

I owe my success to your devotion to having children who want to leave this world better than they found it, and to be a part of something greater than one's self.

I look back on my life and I see how I was influenced by your humility, your patience, and your selfless pursuit of

helping others. You brought in the poor and unfortunate souls to our home and fed them and gave them jobs. You always believed in the goodness of all people. You looked past their circumstances, showed compassion, and gave them hope.

FRASER: Your thoughtfulness and dedication inspire me to no end. You have exuberance and energy to spare after raising three rambunctious boys, and you are always thinking of others. Case in point: when I proudly watched you cross the finish line of your 25th marathon, your first words to me were, "Can I get you anything? Are you hungry? Thirsty?"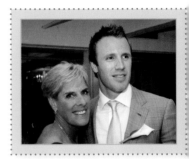

The lessons you taught me along the way stay with me today, none more so than when you would say, "If you're going to do something, anything, do it to your fullest potential." I take that advice and apply it to everything I do, Mom. I hope you will always see that. You have helped me become the man I am today, but I will always be your baby boy.

REMIGIO: Over the years I've seen your hair change from dark brown to gray to white—and I take credit for some of those whites—taking you on my roller-coaster life of health issues, my broken relationships, or some of the sibling squabbles you had to endure. Through it all you have been a pillar of strength, faith, and wisdom to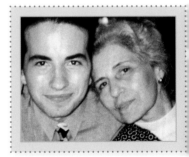
Dad, your brothers and sisters, and your children.

How many tears you have shed for your eight kids through all the hardships that you have seen in your 80 years? Your hair is white for you are Joana "The Wise." You are always giving advice and helping those in need before helping yourself.

You have been my voice of reason, my greatest fan, and my life mentor.

I love you, Mom, my mother, my star.

CHRISTY TURLINGTON BURNS

María Elizabeth Parker Turlington

Dear Mom,

This is a letter that I have written in my head many times. It's a letter of gratitude. I want to thank you for so many things, above all, giving me life. I know now that is no small thing. Giving birth is an act of love never to be taken lightly or for granted. To carry a child, give birth to and then raise her is probably the most generous thing that one human being can do for another. And you did this for me and for my sisters. This might have been enough, all you had to do, but then in your motherly way, you continued to give and give and still do.

Above all else you have taught me that being a mother is a commitment, and once you are a mother, you are a mother for the rest of your days.

I also know now that mothering can be thankless work at times. It can be all consuming, leaving little time for yourself without someone attached to you literally, physically. Many of us go into this role knowing that there will come

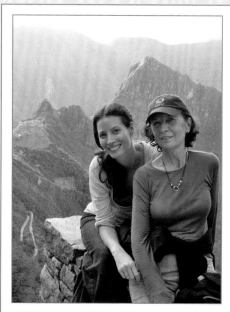

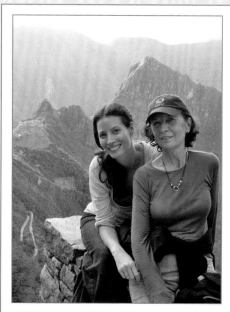

121

a day when our baby finds her voice and has opinions of her own and will confront, defy, and question ours. I know that this is part of what being a mother is too. And from these confrontations, individuation and self-reliance can emerge.

As I get closer to these days myself with each year that I am a mother, I am reminded of our dance over the years.

You taught me that it's never too late to learn new things, see new places, or make new friends. You taught me that traveling the world was the best way to find my place in it and that the greatest wealth is one's family.

> *Above all else you have taught me that being a mother is a commitment, and once you are a mother, you are a mother for the rest of your days.*

Thank you for teaching me through your actions more than your words.

I love you,
Christy

I love you, Mom,

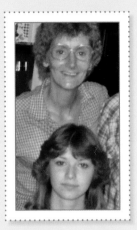

I miss you and wish every day of my life that we could have lunch together, make Sunday dinner for the family in my kitchen, take long walks, talk about life, love, our ups and downs, and just be together. There is no one like you, my dear mother. Never anyone so willing to sacrifice everything for my happiness, or brim over with such deep pride when I sing well or write a new song. Nor anyone who feels my pain or celebrates my joy the way you did. I was an extension of you and you of me like only the unconditional bond a mother and child can know. I could feel you living my experiences alongside me as if they were your own. You pushed me when you knew I needed to be pushed, comforted me when I was broken and lost, listened when I needed to vent and ramble on about myself. You smiled with sincere pleasure to hear me carry on about everything that mattered to me as if I was the most important person in the world. I'm sorry I didn't have the maturity to return the humble, selfless attention you gave me. That we ran out of time so early in life. I understand you much better now, Mom. Now that I am a parent, a wife, a woman who faces her own challenges in life.

I know now the personal loneliness you must have felt spending much of your adult life without your own mother. I remember you would cry at the drop of a hat at the mention of her name and how much you missed her. I know you wished she was still there to help you with your children, to pick blueberries on the weekends and bake pies, make homemade bread, and just spend quality time as beloved friends. I longed for you at every turn in my own life and wished over and over again that we still had each other. I felt lonely for you when I was pregnant with my son. I

didn't have you to call with all the daily questions I had along that journey, and I feel sad that you will never know him.

Sometimes it's the simple things that make me feel empty, like the call I couldn't make to ask what went wrong with the molasses cookie recipe I followed to a tee. You hand-jotted it down in one of Grandma Eileen's old cookbooks, and there was obviously a step or two you must have done by heart, so needless to say, mine were a flop. I can still see your hands so vividly, dusted with flour, working the batter. The same hands that spanked me when I was out of line, trimmed my bangs, zipped up my snowsuit, pulled on my socks, caressed my forehead. The details of your hands always stayed with me and my heart breaks every day knowing that I will never feel their touch again. A finality that left such a feeling of helplessness and it is as strong today as it was the day you left. I was robbed of you way too soon. Taken from me when you were only 42 years old. No warning, no mercy, just gone. The overwhelming shock I felt the second I was told that you were killed in a car accident still resonates through me even now, 27 years later.

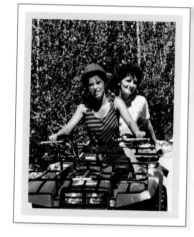

I lost so much the day you died. A pillar of my foundation crumbled. My biggest cheerleader, the one who would stand up to anyone for me, the person who was always on my side, was gone. I wish I had the chance to thank you now and share all the wonderful things in my life and spoil you. You suffered so much through personal hardship but still always did your best for me, and I know it hurt you to not be able to do more. You lived for your children and I only wish I could return that love. I can't have you, but I keep you close in my thoughts and remember you as the dearest mother I could ever have wished for. There was only one you, Mom.

Love always,
Eilleen

SUZY UNGER
Barbara Rose Brooker

Dear Mom

("Barbara" as you preferred, during one of your many evolutionary transitions),

When I was little, I so badly wanted Mrs. Brady. I'm sure she was a PTA mom, classroom mom, bake sale mom, carpool mom, sign-up-for-anything mom. I'm sure when Marcia Brady came home from school she had a perfect sea-blue unchipped china plate with three homemade warm chocolate chip cookies and a glass of milk. I bet she even had a clean place mat and yellow linen napkins.

You were Gertrude Stein mom. You were going to college. I think they called you a reentry mom back then in the '70s. You took three buses to city college, transferred to SF State, and got your master's. Now you're 77 years old and teaching creative writing there. My hero.

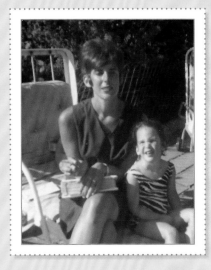

I used to come home in the afternoons to a kitchen just filled with wads and wads of crumpled white typing paper. You were always writing, your back facing me as you sat typing away and peering into Joe and Dave's flat next door. Joe was dying of AIDS. When everyone else in the world was terrified of this newborn killer, you took him and Dave in, fed them, loved them, and nurtured them. You ended up writing a beautiful book called *God Doesn't Make Trash*, which will someday be made into a movie. I promise. You are a success-

125

ful author. You have written 16 books. Just because they weren't *New York Times* bestsellers doesn't mean they aren't great works of art.

You may have not had time for school volunteer stuff, but now, I wouldn't change a thing. I am so proud.

You are a pioneer. You are courageous. You taught me what it looks like to be strong, independent, fierce, and beautiful.

Your beauty comes from your undeniable individualized style. You wear giant silver rings and bracelets and chokers. They all tell a different story. That is what you do.

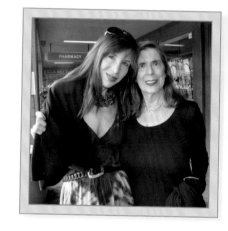

You are a storyteller. And the greatest story of all is that Suzy and Barbara have been through it. And they love each other in a silent transformative way, undetected by the perfunctory afternoon, morning, or evening phone calls. The stories and love are hidden in the silence.

Our stories are intertwined. I experience you as a woman who knows who she is . . . Sometimes I wish that we could start all over again, knowing what we know now . . . But we can't.

And so, I choose to live every day in awe of the courageous woman who raised me to be independent, strong, and defiant in my own growth and recovery.

I love you forever.
Suzy

ANNIE VERON
Joy Veron

Dear Mom,

It's been 15 years since the day I realized something amazing.

I have a superhero for a mom.

Even though it's a story we both know so well, here's the version I remember as a 5-year-old on that day in 1999 in Pagosa Springs, Colorado. I put on my favorite bright pink and ruffled bathing suit, eager to get to the hot springs and swim. Chloe, Elliot, and I could hardly wait because you always knew how to build suspense—

telling us how the warm water bubbled up through the rocks, how people traveled for miles to swim because it had healing powers. It sounded like magic!

On the way, I was disappointed to learn that we had to make a pit stop at a cabin that we were going to rent for Christmas. That pit stop became more than a pit stop. What happened there never left our lives.

Chloe, Elliot, and I laughed and bickered like always as you got out of the car with Dad, Nana, and Baba to sign paperwork. Waiting in the car, I was admiring the beauty of the large cliff that the house was situated on, when our Suburban knocked out of gear and started rolling toward the cliff. I was young, but I knew fear. My first instinct was to look wildly for you: our protector. You were standing outside the cabin when you saw the car. I remember the look on your face. It wasn't fear. It was stone-cold determination. Everyone else had frozen in horror. But you ran. No, you didn't run. You flew.

127

You hurled yourself in front of the SUV, arms outstretched like you could stop it. For a dim moment, my 5-year-old mind believed that you could. The determination never left your face as your slight, 100-pound body vanished underneath the car. Chloe and Elliot and I felt a bump as we ran over your body.

Without you, there wouldn't have been a bump to cause one of the doors to swing open so that Baba could jump in and pull the emergency break. Without you, I wouldn't be sitting here today. Without you, I wouldn't believe in superheroes.

Yes, you are paralyzed from the waist down and life gets tough at times, but you know, Mom, none of it ever stops you. I see the same determination I saw on your face on the day of the accident every single morning. You make sure to be at every tennis match, you listen to every detail of my college life. You encourage me to be anything I want to be in this world. But the ultimate truth is that all I want to be in this world is you.

I want your passion that leads you to keep fighting and hoping and living and loving. I secretly know that you would love to go back in time to walk, run, dance, and jump for just one more day. I know you must think about it and dream about it. But I also know that you

wouldn't trade it for the world because we are alive and with you. And how many people can say that the last time they ran, they saved three lives? Three lives that you keep saving, every day, by being the mother you are to us.

A few years after the accident, you were at one of my soccer games and hit a pothole on the ground that sent you flying out of your wheelchair to land in a tangled heap in the grass. As you lay there, staring at the blue sky, you said something I have always remembered: "You can either laugh about it or cry about it, and I think it's better to laugh about it." At any point in my life when I can't seem to pick myself up, I think back to that very day and remind myself that I have living proof that good can in fact come from bad. Joy can come from pain. And that is what has happened. You are Joy. It's your name, and it's who you are.

I know you're always sad when I go away for school and always ask me to "come back to you," but don't forget this: I promise I will always come back to you. Never forget that I will always come back to be with my superhero, who doesn't even need legs, because, Mom, you can fly.

Always Yours,
Annie

Dear Mom,

I could not have gotten through most of my 25 years on this planet without you. You helped me grow, you taught me things, and most of all, you loved me. You raised me from a stubborn little brat to a proud and successful woman. I know when I was younger, I might have been a little pain in your rear, but hey, what kids aren't?

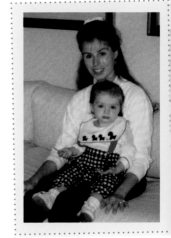

I never knew as a kid how hard it sometimes was to give me the things I needed in life. I never knew until I was older that you had sold some of your most precious belongings to get me things I wanted for Christmas or needed to get through school. You sacrificed everything you had and a little bit more. The things you did for me always had one thing in common: they were going to benefit me in the future.

Growing up, you were never embarrassed or upset with me when I acted "differently" from everyone else. I know I was not your typical teenage daughter (especially when I was goth), but that didn't change how you treated me. You saw right through the baggy pants and knew I was still a normal human being. You let me be me and always defended me if anyone gave me any trouble. You knew it was only a phase, and to everyone's surprise, you were right (good thing, because I was tired of sweating in all black throughout the summer). You never tried to push me toward something more "girly" like cheerleading. You even let me play on the boys' varsity ice hockey team and supported me through it all. You gave me something that most people can never experience: confidence. I have such strong confidence now about how I am, who I am, and what I am.

As a young adult, I moved out and we became a little distant. Then, cupcakes came into play. We took classes together and started baking out of our homey kitchen. Soon WickedGoodCupcakes was born! We poured everything we had into the business, supporting each other when one of us thought it was an impossible task. It was during this time that I learned to do something I never thought I would have to do: treat you like a coworker and put the mother-daughter feelings aside. It was hard, arguing with you was never my forte, but I had to. I needed you to understand that I was an adult now and needed to be treated like one. I couldn't be your little girl in this business; I had to be your business partner.

Overall, I'm proud of it all. We've done something that other mothers and daughters wish they could do. We sacrificed so much to make a name for ourselves, and I couldn't be any prouder of what we have become. And what could be better than doing it with the person who knows me the best? We've been through it all, the good,

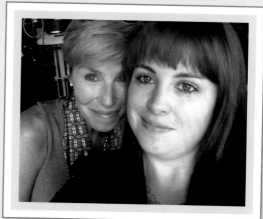

the bad, the ugly, and the beautiful. I can't thank you enough for all that you have given up for me. You are an amazing woman who went through hell and back multiple times and proved to the world that anything can be accomplished, no matter how hard the task.

I hope you can read this and understand that this is all from the heart. No bullshit.

As I continue to grow and become older with each passing day, don't think for a second that I will grow out of needing you in my life. I couldn't imagine a second without you here. I love you, Mom. What can I say? You're one bitchin' mama.

Love forever and always,
Dani

Mom,

It was pretty brave of a Southern belle to leave Memphis, Tennessee, the day you graduated from college, for New York City. You were the first Jewish cheerleader at East High and the first nominated for the Homecoming Court—you had a good thing going! But I'm

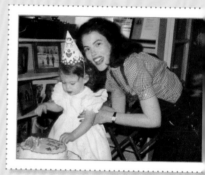

glad you did leave and started working at *The Ed Sullivan Show* because you met a producer there, an older man (Mom!!!!), who turned out to be the love of your life and my dad.

I'm not sure who you have taken care of the most, between Dad, Elizabeth, me, and some of our pets—Lily, our dachshund, did go to an allergist an hour away! I think we have taken turns over the years, but you gave everything you had to whoever needed it the most.

Thank you for all the times it was me—in other words the last 38 years, 24 hours a day. I always laugh when people say a mom takes care of her babies until they are 18. You still drive me to the airport, pick up my prescriptions, remind me to change the oil in my car, get my license renewed, and postpone my jury duty. You know where my kids' birth certificates are, pay my cell phone bill, and take care of me when I have migraines.

For the past few years, it has been Dad's turn. You never burden Elizabeth or me with anything. Somehow your 102-pound body is strong enough to take care of him, make his breakfast, lunch, and dinner, chauffeur him to doctors' appointments and shaves, make sure he has the right pillow for his back so he can

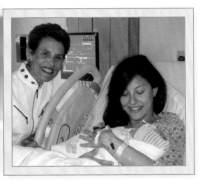

watch the movies he loves, the right drops for his eyes so the one that has some vision can try to read his beloved scripts, and the right position at the table so he can be the most comfortable and hear the most conversation. You do this every single day without help because he wouldn't like that.

But what about you? Aside from swimming six days a week for 40 years (this is not a trait I inherited!), doing the *New York Times* Sunday crossword puzzle, and peer counseling at a mental health facility, you put our family's needs ahead of your own. And you don't want any thanks. You do it because it is who you are as a mom.

And through all of life's ups and downs, you instilled in me the notion of giving back, by example— volunteering at the ER for 20 years—and by teaching— taking me to work at the food bank on Sunday mornings throughout my childhood.

Thank you, Mom, for being our family's backbone, for being president of the PTA, for walking our dogs every day when we promised to, for never sitting down, for taking me down the water slide in Hawaii against your will, for teaching us to love dessert, for picking the names Sloane and Graham for my children, and for putting family first, second, and third.

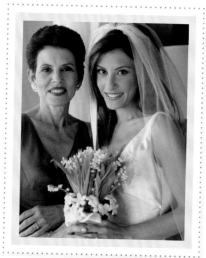

I love you so much!
Norah

mama . . .

I need to tell you how much I love you
and appreciate you . . .
I need to thank you for all of the
sacrifices you made to make me me . . .

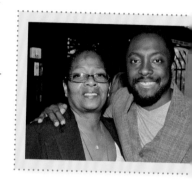

Thank you for designing me . . .
Thank you for programming me . . .
Thank you for investing in me . . .
Thank you for developing me . . .
Thank you for installing morals in my
system . . .

although it was painful:

Thank you for disciplining me . . .
Thank you mama . . .

I want to go to the ends of the earth and tell the world how
amazing you are . . .
I want to write it in the sky . . .
I want to graffiti it on the White House . . .
I want to write it in a book . . .

Even if it isn't my book . . .

 "my mama is better than your mama"
 (for me)

I know there are billions of mothers on earth . . .
But . . .
you are the best mother a will.i.am can have . . .

 will.i.am

 Sent from my heart

Dear Mom,

I never knew what an inspiration you were to me until I started raising my own daughter these last two years.

It's difficult to fathom that you came to the United States with nothing but a little money and a lot of hope to raise your kids here for a better future.

I recall when we were little how embarrassed I was to be Chinese, to be different, as I wanted to assimilate so badly to the Western culture.

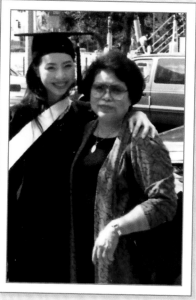

You were adamant about us speaking our native tongue, Mandarin, and admonished us that one day we would thank you for it (and we continue to thank you for it today).

I recall the countless times you were treated unfairly as an immigrant, to be called incendiary names such as vietcong, gook, and chink.

I was too young to understand what was going on, but I always felt the pain inside you for not being in a familiar environment, speaking hardly any English.

You had four children to take care of and kept your chin up and made ends meet for us. You were always so positive and gave us light.

As I became an adult, you were forever supportive in everything we did (even allowing me to pursue the film business, which is unheard of in our culture). I know you never understood my

135

profession, you laughed often about it and jokingly said to me, "I hope you can make a living."

I recall the days that I could finally afford to buy you whatever you wanted. But you refused and continued to be frugal . . .

To be rebellious, I bought you items that I knew you would love. After you passed away, I cleaned out your closet and saw those items unused, wrapped so carefully and in perfect shape— I cried knowing that you cherished them but didn't want to put any wear on them because "they are so nice." I can just hear you saying that.

Before you left this earth, you told me that daughters are the best and that you hoped that if I ever decide to have children, to make sure a daughter is in the cards.

When I was five months into my pregnancy and was told I was having a little girl, I smiled and knew you had a hand in this miracle.

Today, she's a dream to have and, like her father says, a gift from the heavens. Having one child is a handful so I have no idea how you managed to raise four on your own!

You are truly the best, most generous woman I've known in this world. I love you, Mama. And I know you would be proud of what I've become . . . You gave me the American dream.

Eternally yours,
Nina "Jia Jia"

Mom,

Whenever I come home to visit and we are on the couch, you sit close . . . like *really* close. You say it's because you miss me, and I get it, I do. And even though I give you a hard time as I scoot to the other side of the couch, I want you to know I feel your love and

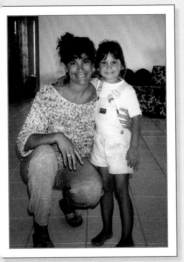

I am grateful for it! I am always amazed that you are the mother of four children and you have the ability to make each one of us feel as if we are your one and only. You are my best PR person, my confidante, and the woman I am so proud to call mom.

I also know that along with your sweet and sentimental ways, you have a major badass side. Born and raised on Long Island to a teenage mom, you know what it's like to struggle. You took every opportunity to make the best of what you had—and I know it wasn't much— by fully dedicating yourself to school and competitive swimming. *And I wonder where I get my type A personality?*

You did your research and found the best college diving coach and then drove halfway across the US to attend Michigan State University (so brave!). And I am so glad that you did because that is where you would eventually meet Dad!

A New Yorker out of her element, you did what you do best: buckle down and get to work. With nursing as your major, your focus turned to the infants in neonatal care. Those babies meant everything to you as you watched over every finger and toe as if they were your own children. And while I am always amazed at the technical part of your job, I am most proud of your quiet, caring moments. You sat with so many families as they prayed for

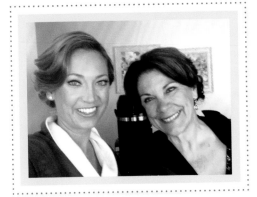

their new bundles (most barely a bundle) and comforted them as they tried to make sense of the tubes and machines keeping their babies alive. You made them feel that it would all be okay. You are so incredible in difficult circumstances.

Now, to watch you combine that knowledge with decades of experience and bring it to the classroom as a teacher has been incredible for me to see. I am so excited that others get to learn from such a strong and brilliant woman.

I know I've often teased you for not being able to sit still, but I want you to know how inspiring you are to me. You always go above and beyond. I couldn't imagine going back to school as an adult and yet you went on to get several graduate degrees *while raising us!* When you came home from a long workday, you made a constant effort to keep the house clean, get out to the garden, or plan a family event. And when I was 15, we watched you become a mother again. You are like a medical miracle having my little sister at age 49—no slowing down for you!

You always take my jokes and prods with grace and I hope you know that this is my way of loving you. My love is so deep. My respect is so great. And now that I am newly married and beginning a family of my own, this reflection on our relationship is making me see you and the sacrifices you made more clearly than ever before. I have a ton to live up to if I get the chance to be a mom.

Thank you, Mom. I know appreciation is all you ever need . . . I need you, I love you, and I am *so* so fortunate that you are my mom.

Love,
Ginger

Dear Mom,

I want to let you know that I took a lot of shit because of you. It's true. For many years, I was the kid that got pushed around and made fun of simply because I loved you so much. I was the kid with *mamitis,* the mama's boy.

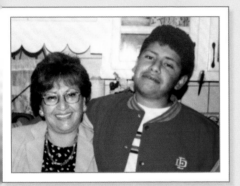

I guess I never really tried to hide it. Every time you picked me up I'd hug and kiss you. I'd often start sentences with, *Well, my mom always says . . .* I even looked forward to having you at my school's events. Seriously, what kind of kid does that!

So the pushing and shoving came in droves. *Donde esta tu mami, eh?* My masculinity was questioned, my cool factor never had a chance, and the days were long and miserable.

That's what I endured for you, Mom. I'll give you a moment to let that sink in.

And another thing: thank you.

Thank you for always asking me about my day.

Thank you for indulging me in my nerdy endeavors without any judgment. Not once did I see you laugh or give an eye roll at my ardent defense of the realness of WWF wrestling. *(That is so not fake blood!)*

Thank you for teaching me how to iron my clothes and do laundry, despite some of your comadres telling you that is not what boys are supposed to do. *I don't care! I want you to be a self-sufficient person, not an incompetent man.* Right on, Mama.

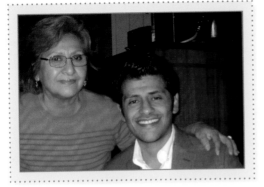

Thank you for always (always) being worried about me. Pretty much all day every day. You cramped my style, but I know why you did it: you were worried for good reason.

Your boy was a sickly one with asthma, weak lungs, and a penchant for anxiety. In all, I was a regular bout of insomnia for you. There I was at 1 a.m., lying on my bed and sweating through my X-Men pajamas, wheezing and coughing so often that my lungs felt like they were set on fire. You sitting next to me, switching among half-a-dozen different medicines, rubbing my chest, holding a mirror over my mouth to check if I was still breathing. And throughout the night, as you calmed me down, as you made me well, you'd be smiling, trying to comfort me, but failing miserably to hold back your own tears. *Ay mijo, la mugre asma.* Thank you for never ever being too tired for anything. This baffles me. How did you do it? All those nights where you slept no more than a couple of hours, yet you never said no to being an amazing mom. You never said no to driving me to the comic book store one town over or taking me to see the latest disaster movie or making me a hearty breakfast or packing the lunch that made all other kids slouch in envy. Not once.

Thank you for being my cheerleader. You may never know the full extent of it, but that devoted support got me through many dark moments, moments of emotional and physical weakness.

Some things have definitely changed since then. Over a decade later and here you have me: healthy, hopeful, and still a nerd (some things don't change, ever). I have no idea how you made this out of a flabby kid with knocked knees and breathing issues, because, yes, this is all you.

Te quiero, mi madrecita,
Himay

BIOGRAPHIES

Jennifer L. Arnold, MD, MSc

Dr. Jennifer Arnold is board certified in both pediatric and neonatal medicine. She is currently an attending neonatologist at Baylor College of Medicine and medical director of the Simulation Center at Texas Children's Hospital. She is married to her best friend, Bill Klein. They live in Houston, Texas, and are parents to Will and Zoey. Jennifer and Bill are also the stars of TLC's *The Little Couple*.

Felice Keller Becker

Felice is a freelance writer and an award-winning songwriter. Her mother, Lee, is her biggest cheerleader. Lee is a devoted wife, mother, grandmother, and friend who lives in Seattle with her husband of forty-five years. Felice says her mother taught her the value of giving back to those in need and that motherhood is the most important job she'll ever have. Felice lives in Los Angeles with her husband and their daughter Jessica.

Michele Tracy Berger

An associate professor of women's and gender studies at the University of North Carolina at Chapel Hill, Michele Tracy Berger is also the founder of the Creative Tickle, a coaching practice that helps individuals and organizations to harness the power of creativity. Michele says her mother changed the trajectory of her life, allowing her to become the woman she is today: a writer, professor, and yoga teacher.

Trish Broome

A freelance writer and social media specialist, Trish Broome has been an avid writer since middle school. She shares many of her personal stories on MixedNation .com, a website dedicated to celebrating cultural diversity. Trish says her mother is the strongest, most dedicated and independent woman she knows, and she models her life and compassionate nature after her. Trish lives in Halethorpe, Maryland, with her husband and three pets.

Patricia Burgess

Patricia Burgess spent more than thirty years as a corporate attorney. Her passions include her family, writing, running, hiking, bicycling, and traveling. She self-published a biography about her father, a beloved college coach, teacher, and mentor, entitled *Smart Jocks, Long Talks and Pink Socks*. Today, she continues to write letters to her mother, Eleanor, who at 91 years old is still curious and full of opinions.

Tom Burns

Tom Burns is a husband, father, and writer living just outside of Detroit Rock City. His work has been featured on the Huffington Post, the Good Men Project, xoJane, 8BitDad, and various other blogs. Tom also founded BuildingALibrary.com, a website devoted to helping parents find the right books for their kids. His mom, Eileen, recently moved one block away from him and he says doesn't even mind . . . seriously.

Kristin Chenoweth

An Emmy and Tony Award–winning actress and powerhouse singer, Kristin Chenoweth has graced the stage and screen in megahit shows, including *Wicked* and *Glee*. Kristin is also a passionate supporter of causes, such as breast cancer awareness (her mom, Junie, is a cancer survivor), adoption advocacy (Kristin was adopted at five days old), and organizations supporting animal welfare (because she loves her dog). Kristin says her mother gave her the greatest gift you can give a child—a healthy self esteem.

Liam Cole

Liam Cole, born and raised in Hollywood, California, is in the fifth grade. He's a Dodgers fan, loves playing baseball and piano, and is following in his parents' footsteps, pursuing acting. Liam is very protective of his two younger brothers, Hudson and Kingston. He is proud to be a mama's boy and says there is no place he'd rather be than with his family.

Robert Cole

Robert Cole is a journalist, poet, public speaker, and teacher whose love of the written and spoken word was nurtured by his mother, Lillian. He's also worked in the performing arts as a musician and stage actor. In 2011, his poetry book *The Life of the Body* became the inspiration for the modern song cycle "Something About Autumn." Robert grew up near Lake Michigan and remains a lover of all the creatures and the great outdoors.

Cat Cora

Cat Cora is a world-renowned chef, restaurant owner, author, and television personality. In 2005, she made TV history by becoming the first and only female Iron Chef, winning Food Network's *Iron Chef America*. Cat is also the president and founder of Chefs for Humanity. She credits her mom, Virginia, for instilling in her a passion for her career, as well as a passion for helping for others. Virginia is a nurse practitioner and an avid outdoorswoman who can also hold her own in the kitchen. Cat lives in the Santa Barbara with her wife and biggest fans—her four sons.

Sarah Ferguson, the Duchess of York

Sarah Ferguson, the Duchess of York, is an author, entrepreneur, television personality, film producer, and passionate philanthropist. She is the former wife of Prince Andrew, Duke of York, and the proud mother of Princess Beatrice and Princess Eugenie. Sarah's mum, Susan, passed away in 1998; she was a polo enthusiast and documentary filmmaker who loved making films about horses.

Amanda Fortini

Amanda Fortini is a journalist who has written for *The New Yorker, The New York Times Magazine, Rolling Stone, Wired, The New Republic, New York, Slate, Salon,* and *Elle,* where she is a contributing editor. Her mom, Patricia, taught all three of her daughters never to limit their thinking. "There's always a way," she'd say, or "You'll figure it out." Her think-big philosophy is probably why Amanda is now a writer living in beautiful Montana.

Glory Gale

Glory Gale is a former celebrity segment producer for *The Ellen DeGeneres Show*. Her mother, Kathleen, lives in Northern California and owns two businesses—an insurance company and a catering business. According to Glory, the best trait they share as mother and daughter is their exaggerated reactions, most often expressed at the same time.

Lisa Goldman

Lisa Goldman is a wife and mother of two children. Despite having no known risk factors, Lisa was diagnosed with stage IV lung cancer in January 2014. After her diagnosis, Lisa learned that lung cancer kills more women each year than breast, ovarian, and cervical cancers combined. She began blogging in hopes of raising awareness. Lisa's mom, Barbara, taught her through examples how boundless a mother's love can be. Now Lisa tells her own kids, every day, that she loves them without condition and nothing they can say or do would ever change that.

Josh Groban

A world-renowned singer, songwriter, musician, and all-around great guy, Josh Groban has been a global pop star for over a decade. His first four solo albums have been certified multiplatinum, and to date he has sold more than 25 million worldwide. Groban was the host of *Rising Star* on ABC and has appeared on film and in television, including roles in *Glee; The Office; Crazy, Stupid, Love;* and *Muppets Most Wanted*.

Luis Guitart

Luis Guitart is a recent college grad now working in corporate America, just starting to get acclimated to the real world. Inspired by his mom Sheny's thimble and miniature spoon collection, Luis has started many collections of his own, including key chains and political bumper stickers. His dream is to be a cast member on the *Real Housewives* franchise, but if that doesn't pan out, a career in media and public relations would make him equally content.

Mariel Hemingway

Mariel Hemingway is an Academy Award–nominated actress, author, healthy-lifestyle advocate, mother, and celebrated speaker focused on optimizing the lives of people of all circumstance and ability. In 2014, the documentary she co-executive produced with Oprah Winfrey about the Hemingway family entitled *Running from Crazy* was nominated for an Emmy Award. Mariel's beloved mother, affectionately known as Puck, died of cancer in 1989. She always told her daughters that "pretty is as pretty does."

Lisa Hirsch

Lisa Hirsch is a popular blogger with a worldwide audience. When she found out her mother, Ruth, had been diagnosed with Alzheimer's disease, her love, appreciation, and caring for her mother was transformed. Her first book, *My Mom My Hero*, tells the powerful story about their relationship through a series of entries from her blog MommyHero.blogspot.com. Lisa lives in Manhattan with her husband and has one loving son.

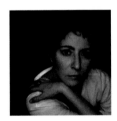

Susan Jaffee

Susan Jaffee was a television writer/producer for nearly twenty years. Some of her credits include *Cybill, Sex and the City,* and *Desperate Housewives*. She currently lives in Asheville, North Carolina, where she is privileged to work in hospice care and continues to write, heeding the frequent advice of her late mother, Joyce: "Never write down what you don't want the world to know." Susan wrote this letter to her mom in hopes that the world *would* know how much her mom is loved and missed.

Sonia Kang

Sonia Smith-Kang is a blogger and the creator of Mixed Up Clothing, an ethnic-inspired children's fashion brand that has been featured on NBC's *Today* show and *Huff Post Live*. Sonia's mom, Irene, taught her that no matter what curveballs life throws, she has the strength and courage within to fight and succeed. Sonia is married with four children and lives in Los Angeles, where she volunteers and is a board member with both Multiracial Americans of Southern California (MASC) and Northridge Hospital Foundation.

Katrina Kenison

Katrina Kenison is a writer who has traced the seasons of a woman's life through three books: *Mitten Strings for God: Reflections for Mothers in a Hurry; The Gift of an Ordinary Day: A Mother's Memoir;* and, most recently, *Magical Journey: An Apprenticeship in Contentment.* Her mom, Marilyn, is her best friend and favorite companion—whether they're working on a craft project, taking a road trip, or visiting a flea market, where they invariably fall in love with the same things.

Lauren Keppel

Lauren Keppel is a licensed clinical social worker in Illinois, providing counseling to women who have experienced trauma. She is the mom to a wise-beyond-his-years and pretty darn entertaining little boy. She spends her free time boxing, getting lost inside a good book, and whipping up mass quantities of baked goods for her loved ones. Lauren inherited her fighting spirit, her appreciation of literature, and her love of food from her mom, Amy, who is her greatest soul connection.

Ali Landry

Ali Landry—actress, host, and former Miss USA—launched her career in Hollywood as the first spokeswoman for Doritos during the 1998 Super Bowl commercials. This Southern girl is now a married mom of three who juggles taking care of her busy family and her career. She is also the founder of Favored.by, a mobile app that helps moms find the best products for their kids, and she and her company are the creators of the Red CARpet Child Safety Event, raising awareness for child passenger safety.

Michael Levitt

Michael Levitt is an American television producer of award shows, reality shows, game shows, and specials. When Michael is not producing, he can be found in shelters all over Southern California, saving dogs and placing them in loving homes. One of Michael's mom's greatest joys is seeing her son stepping up and giving back to the world. The apple doesn't fall far from the tree: Michael's mom, Marian, was a teacher for sixty years and still enjoys substitute teaching.

Monica Lewinsky

Monica Lewinsky is an activist for eradicating shame and humiliation on the Internet. She holds an MSc in Social Psychology from the London School of Economics and Political Science. Her mother, Marcia, is a former social worker and writer. When they are together, it's not uncommon for them to break into song—usually show tunes. Monica's strong sense of compassion and gratitude were instilled in her—and her brother, Mike—by Marcia.

Lisa Ling

Lisa Ling is an award-winning journalist, writer, and author who has been working in television for nearly two decades. Most recently, she hosted and executive-produced the critically acclaimed documentary series *Our America* on OWN: Oprah Winfrey Network. She is now the host and executive producer of *This Is Life* for CNN. Lisa's mom, Mary, is a Taiwanese immigrant and was the head of the LA office of the Formosan Association of Public Affairs—a nonprofit organization that seeks to build worldwide support for Taiwan independence. Lisa lives in Santa Monica with her husband, Paul, and her beautiful daughter, Jett.

Mikki Linton

Mikki Linton is 22 years old and lives in Warsaw, Indiana. She enjoys spending time with her family and is often found in the kitchen with her mom, Tracy, helping prepare their Sunday family dinners. The best gift Mikki's mother ever gave her was life, twice. After Mikki was diagnosed with lupus in 2012, Tracy donated a kidney of her own to save her daughter's life.

Ruth Lofgren

Ruth Lofgren lives in northern Minnesota, and though she is a retired high school English teacher of thirty-six years, she still substitute teaches part-time so she can stay in touch with students. Ruth was the English major, but Margaret, her mother, could still correct her usage and come up with the tough answers in the Sunday crossword puzzles.

Peter MacQuarrie

Peter MacQuarrie started writing creatively in the sixth grade, crafting prose for the school newspaper. Now his work has appeared in many magazines and anthologies. When he looks at the stars on a clear night, he remembers how his mother, Belva, encouraged him to study astronomy. She became the biggest star in his life, always outshining the others in the sky. Now that his mother is gone, Peter remembers how she blessed him with a big and caring heart.

Carolyn Mason

Carolyn Mason lives in Colorado Springs, Colorado, and is in the third grade. When not in school, or eating her mom Whitney's fresh banana bread, Carolyn likes playing soccer, skiing, riding horses, and going camping with her family.

April McCormick

A nationally recognized writer, parenting blogger, and mother to a young son, April McCormick credits her mom, Nancy, for encouraging her love of writing; it was Nancy who gave April her first journal, for her tenth birthday. Both live in Louisville, Kentucky, where April just loves having her mom nearby so she can pop in anytime she wants for Nancy's famous Ugly Salad—a salad of wild rice and fresh herbs—which is April's favorite dish in the world.

Dr. Phil McGraw

Since 2002, Dr. Phil McGraw has been hosting his leading daytime talk show, *Dr. Phil*, providing the most comprehensive forum on mental health issues in television history. He is a #1 *New York Times* bestselling author several times over, and his most recent title is *The 20/20 Diet: Turn Your Weight Loss Vision into Reality*. In 2003, Dr. McGraw established The Dr. Phil Foundation, a charitable organization benefiting disadvantaged children and families. He lives in Los Angeles with his wife of 38 years, Robin, and has two adorable grandchildren.

Robin Meade

Robin Meade is the anchor of HLN's morning show *Morning Express with Robin Meade* and serves as co-host with Dr. Sanjay Gupta for *AccentHealth*, a program focused on consumer-related health stories. Robin is also a country music artist and the author of the *New York Times* best-selling book *Morning Sunshine! How to Radiate Confidence and Feel It, Too*. Her mother, Sharon, has always been her biggest fan and supporter.

Sarah Monson

Sarah Monson is a writer and recovering reality TV casting director who cast hit shows, including *Survivor, The Bachelor, Cash Cab, Blind Date*, and *Whose Wedding Is It Anyway*? Her recent book on the subject, *Me On TV*, is an Amazon bestseller. She has also written lifestyle and pop culture pieces for AOL, Yahoo!, SheKnows, xoJane, Hello Giggles, E! Online, and *Cosmopolitan* magazine. Sarah's mom, Kim, was an artist, a dog person, and a selfless, beautiful, and unique sparkle in the eyes of all who knew her during her abbreviated time on this earth.

Nancy O'Dell

Nancy O'Dell is an Emmy Award–winning entertainment journalist, bestselling author, entrepreneur, philanthropist, and co-host of the most-watched entertainment news program in the world, *Entertainment Tonight*. Nancy frequently contributes to *CBS This Morning*. She is the creator of a series of children's apps and books called *Little Ashby: Star Reporter*, and also is the executive producer and host of *Celebrities at Home* on HGTV. Nancy hopes to be as good a mom, wife, and person as her mother, Betty, was.

Suze Orman

Suze Orman is America's most recognized expert on personal finance, a two-time Emmy Award–winning television host, *New York Times* mega bestselling author, magazine columnist, writer/producer, and one of the top motivational speakers in the world. She got her strong work ethic from her mom, Ann, affectionately known as Mama O, who was a legal secretary known for her lightning-fast typing and ability to take shorthand and to repeat back word for word anything Suze said, no matter how fast she spoke. Ann passed away in 2012, with her daughter by her side.

Kelly Osbourne

Daughter of rock legend Ozzy and Sharon Osbourne, Kelly Osbourne is a singer-songwriter, actress, television presenter, and fashion designer. She recently launched her clothing line for all women called Stories . . . by Kelly Osbourne. She won an Emmy Award for E!'s *Fashion Police*, where she has been a panelist and presenter since the show's inception. She has also appeared on *Dancing with the Stars*, in which she and professional dance partner Louis van Amstel took third place. If there is anyone in the world Kelly says she is most like, it's her famous mother, Sharon, who is a host, author, and cancer survivor.

Tejal Patel

Tejal Patel is a former divorce attorney and mediator who reinvented her life to become an author, children's yoga and meditation teacher, and creator of the Astitva Seekers spiritual coaching program. Tejal turned to yoga and meditation to help her cope with the stress, anxiety, and limiting beliefs from her relationship with her mother, Kokila. Tejal says her practice was the saving grace that reestablished forgiveness, spiritual growth, and unconditional love between them.

Ken Paves

For more than twenty years, Ken Paves has been one of the most sought after and most recognizable hairstylists in the world. Oprah Winfrey has called him "the big kahuna of Hollywood hair," and in his work, which has appeared in countless fashion magazines, he has created award-winning styles on some of the most famous heads in the world. Two things for which he credits his mom, Helen, are his love of others and his love of hair. Helen still runs Ken's first salon, which he opened in Clinton Township, Michigan.

Martin Paves

Martin Paves is a writer and film director. His mother, Susan, inspired him to use his imagination to dream and taught him that there was nothing he couldn't do. Martin's mother also taught him to be kind and considerate of others. Martin is grateful that his mom gets to see the wonderful life he has today. He hopes to inspire the world through his eyes and the message of his films . . . and to make his mom proud.

Kate Riazi

Kate Riazi has worked in local and national television news and entertainment production for nearly twenty years, including *NBC Nightly News* and *The Oprah Winfrey Show.* Her mom, Bridget Anne, inspired her journalistic instincts and ability to instantly bond with others since childhood. Kate is a mother of two little ones of her own, and of a nearly human yellow lab. She and her husband enjoy making memories for their family by writing letters to their children for them to read one day when they're grown up.

Melissa Rivers

The daughter of the late comedy legend Joan Rivers, Melissa Rivers grew up in show business and spent most of her career on the red carpet hosting pre-award shows and fashion specials alongside her famous mother. She is the executive producer of *Fashion Police* on E! Network and was the executive producer of the hit reality show that starred her and her mother, *Joan & Melissa: Joan Knows Best?* Melissa lives in Los Angeles with her son, Cooper.

Shaun Robinson

Shaun Robinson is an Emmy Award–winning journalist with millions of viewers as anchor of the entertainment news show *Access Hollywood.* She is the author of *Exactly As I Am,* a book for teen girls about building self-esteem. Also dear to her heart is One Girl, One Voice, a movement Shaun created asking young woman to pledge to use their voices for positive change in the world.

Lisa Page Rosenberg

Lisa Page Rosenberg is a former writer and producer for television and current class chaperone/soccer mom for the PTA. She has been chosen by BlogHer as a Voice of the Year, and her daily family humor blog, Smacksy, has been included in "best of" lists from *Parade* magazine to SheKnows. She credits her mother, Sandra, for not only teaching her how to perfectly fold a fitted sheet and organize a closet, but also for fostering her love of books and learning, and telling her that every person has an interesting story to tell.

Molly Sims

Molly Sims is an actress, model, author, jewelry designer, and humanitarian. She grew up in Kentucky and considers herself a true Southern belle, even thought she now calls Los Angeles home. In her free time, Molly enjoys hanging out with friends, hiking, doing yoga, and spending time with her husband, Scott Stuber, and son, Brooks. She credits her mom, Dottie, for showing her how to be a self-made woman, and for introducing her to her lifelong love of jewelry.

Keller, Molly, and Stephanie Slotnick

Keller, Molly, and Stephanie "Stevie" Slotnick think their mom is a hero. Lainey is a former second-grade teacher and currently a full-time mom who has been married to her college sweetheart for twelve years. When they grow up, Keller wants to be a baseball player, Molly wants to be a soccer player, and Stephanie wants to be a swimmer. The most valuable lesson they learned from their mom is to be nice, be respectful, learn stuff, don't be afraid to do anything, and be proud of yourself.

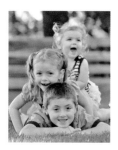

Stephanie Sprenger

Stephanie Sprenger is a writer, music therapist, and mother of two daughters, ages 8 and 3. She lives in Colorado, where she works part-time as a music therapist teaching early childhood music classes. Stephianie is also the co-founder of the HerStories Project, a community of women writers, and is the co-editor of their two anthologies, including September 2014's *My Other Ex: Women's True Stories of Leaving and Losing Friends*. If Stephanie struggles with a chaotic day of parenting, she calls her mother, Chris, who calms her down and reassures her like no one else.

Mindy Stearns

Mindy Burbano-Stearns first drew national attention crowing like a rooster on *The Oprah Winfrey Show*. She went on to procure a successful career in television, film, and radio. Her mom, Joyce, is the force behind Mindy's success and has saved libraries of Mindy's television and film work. Mindy fears she may end up on *Hoarders* when she finally cleans out her mom's house. Mindy also likes to remind her younger brother, Marty, that she is indeed mom's favorite. Joyce pleads the Fifth.

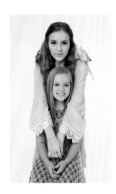

Lennon and Maisy Stella

Sisters Lennon and Maisy Stella are 14 and 11 years old. They both star on the hit show *Nashville*, which makes sense, because they live in Nashville and clearly inherited their talent from their parents, Brad and MaryLynne, the musical duo The Stellas. The girls had their first taste of stardom when their cover "Call Your Girlfriend" went viral on YouTube. Since then, the girls have done everything from performing at the White House, to presenting Taylor Swift with the Pinnacle Award at the 2013 CMA Awards, to playing in front of 80,000 people at the CMA Music Festival.

The Tenors: Victor Micallef, Clifton Murray, Remigio Pereira, and Fraser Walters

Victor Micallef is a Maltese-Canadian singer, songwriter, arranger, and member of the vocal supergroup the Tenors. With the support and encouragement of his parents, he started singing and playing piano at the age of four. Before joining the Tenors, he performed with internationally renowed opera companies around the world. In both his career and as a father, he's always looked up to his mom, Margaret, as a perfect role model and inspiration.

Clifton Murray is a television, film, and stage actor, in addition to being a member of the Tenors. He started singing and songwriting with his father when he was very young. He credits their shared love of music, and his voice, to his grandfather, George Murray, a famous Irish tenor. But from his mom, Deborah—also a music lover—he was taught the importance of faith, hope, love, and compassion to help those in need, and when pursuing a dream, there is no substitute for hard work and determination.

Remigio Pereira is a multifaceted artist whose passion for music crosses all stylistic borders. A singer, guitarist, and record producer, he enjoys mentoring young artists and developing their talent. He started a record label called RemiXN'Mancini and has written and produced Latin instrumental music, hip hop, classical, pop, country, and dance music. As a lyricist he has penned songs, which are featured on the Tenors' multi-platinum-selling records. Born to Azorean parents, Remigio remains close to his Portuguese roots through his love of Fado music.

Fraser Walters is a singer-songwriter, and a former member of Chanticleer, a Grammy-winning a cappella ensemble. Now a member of the JUNO Award–winning group the Tenors, Fraser feels grateful to travel the world sharing his passion for music. He credits his mom for giving him the gift of love and music and says he's the living manifestation of her credo: If you're going to do something, anything, do it to your fullest potential.

Christy Turlington Burns

Christy Turlington Burns, founder of Every Mother Counts, is a mother, social entrepreneur, model, and global maternal health advocate. She was named one of *Time's* 100 Most Influential People, *Glamour* magazine's Woman of the Year, and one of *Fast Company's* Most Creative Minds— all for her advocacy work to reduce maternal mortality around the world. In 2010, she directed the documentary *No Woman, No Cry*, which inspired her to launch Every Mother Counts—an organization dedicated to ending preventable deaths related to pregnancy and childbirth.

Shania Twain

Born Eilleen Regina Edwards in Windsor, Ontario, Shania Twain was raised by adoptive parents, Jerry and Sharon. It was her mom who noticed Shania's talents at a young age and would take her around to "everywhere they could get me booked," including clubs and retirement homes. At age 21, Twain lost her parents in an automobile accident, leaving her to raise her younger siblings. She eventually adopted the Ojibway name of Shania, meaning, "I'm on my way," and set her sights on Nashville. The rest is history.

Suzy Unger

Suzy Unger spent more than twenty-five years in television as a producer, studio executive, and William Morris Endeavor packaging agent. Her mom is her muse, and she hopes to be half the writer her mother is one day. Barbara has been writing novels, poetry, and nonfiction for more than thirty years. Barbara's last novel, *The Viagra Diaries*, is soon to be a television series.

Annie Veron

Annie Veron is currently a junior at Sewanee—The University of the South in Tennessee. Her hobbies are painting, playing the guitar, and playing on her university's tennis team. When she graduates, she hopes to work in marketing and design. Her mom, Joy, lives in Texas, so when Annie is away at school, every night when they talk on the phone they both look up at the moon to stay connected. Annie hopes to have the same amount of determination her mom has in life that leads her to accomplishing the impossible.

Dani Vilagie

Dani Vilagie opened Wicked Good Cupcakes in 2011 with the help of her mother, Tracey. The two of them had taken a cupcake class as a way to spend quality time together, and after their creations became so popular, they realized they could make a living at it. The most valuable lesson Dani learned from her mom is that you can do anything you put your mind to.

Norah Weinstein

Norah Weinstein is the co-president of Baby2Baby, a non-profit that provides low-income children with diapers, clothing, and all the basic necessities that every child deserves. She is a lawyer by training and a former litigator. Her mom, Mary Lynn, advised her that a woman should have a law degree on which to fall back. Mary Lynn hails from Memphis, Tennessee, still says "y'all," has impeccable grammar, and gave Norah the names of both of her children, Sloane (age 6½) and Graham (age 4).

will.i.am

Seven-time Grammy Award–winning artist will.i.am has sold more than 32 million albums around the world with his band, the Black Eyed Peas. He attributes all of his success to his mom, Debra, who as a single mother raised him in a housing project in East Los Angeles (Boyle Heights). In addition to his astounding music career, will.i.am is a producer, innovator, and tech geek who is deeply passionate about encouraging young people to love STEM—science, technology, engineering, and math. will.i.am also stars as a coach on two editions of the hit reality show *The Voice,* in the UK and Australia.

Nina Yang Bongiovi

Nina Yang Bongiovi is a seasoned film professional in a producing partnership with Forest Whitaker at Significant Productions based in Los Angeles. Nina and Forest produced *Fruitvale Station*, which was the winner for both the Audience and the Grand Jury Awards at the 2013 Sundance Film Festival, as well as l'Avenir prize at the Cannes Film Festival. They continue to discover and champion filmmakers who represent individuality and authenticity in storytelling, and are avid supporters of independent cinema. She knows this would have made her mother, Helen, very proud.

Ginger Zee

Ginger Zee is an Emmy Award–winning meteorologist who graces the nation's TVs every day as *Good Morning America*'s chief meteorologist. When not chasing storms and analyzing weather patterns, Ginger has a love of adventure that includes paragliding, iceboat racing, shark diving, and surfing. Ginger's mom, Dawn, lives in Grand Rapids, Michigan, where she is a neonatal nurse-practitioner and teacher at Grand Rapids Community College. Ginger is so thankful for her mom, who gave her enough space to grow as a woman, but more protection than she could ever ask for.

Himay Zepeda

Himay Zepeda is obsessed with finding meaning in life, and helping people achieve a better version of themselves. He recently released his first book, *Gen Y 2.0: How to Thrive as a Millennial*, and his writing has been featured in *The Huffington Post, Lifehack, Thought Catalog,* and *The Good Men Project*. Himay is an unabashed, self-proclaimed mama's boy. His mama, Maria Teresa, is also a serial student, who can't stop learning new fields of study and hobbies. She also loves Googling every prayer ever written.

ACKNOWLEDGMENTS

A special thank you to Lynne and Ruth for bringing me and Ann into this world; without the two of you, this book would not be possible.

Thank you, Ann Satkoski, for your focus and devotion to this special project. I am eternally grateful for your love and dedication to the Letter brand. I could not do this without you. Truth is, I would not want to do this without you. Thank you for making me laugh when I think it's time to give up. Thank you for believing. You are my dear friend, my business partner, and the best mom in the world to the cutest baby on the planet.

Brooks, you were barely out of the womb when we put you to work, but as expected, you were a quick study. You pulled your weight right from the beginning—all 7 pounds of you—and grew quickly into the 3-foot, 35-pound powerhouse you are today. We watched you grow as this book came to life. What a perfect treat for us all. We love you, Brooks. We expect someday you will be writing your own letter to your special mom.

Larry Satkoski, thank you for helping your wife Ann juggle the world of new motherhood while launching a second book in less than a year. We felt your calming presence every day.

Peggy Fitzsimmons, forever the lander of planes. Once again—we look to you for grammatical correctness, can you fix this sentence? Seriously, from grammar to your perfect point of view and your poignant vulnerability, your perspective is so important to everything we do.

Alex Jeffries, what a delight. You are a talented producer with a very exciting future. Thank you for your work on both the cat book and the mom book.

Zach Sundelius, thank you for coming in at the final stretch; your eagle eye is invaluable.

Thank you to Hans Schift, Ashley Mills, Katie Zwick, and the team at CAA.

And thank you to Steven Grossman and Untitled Entertainment.

Katrina Nicholson, who knew a twenty-two-year-old from the Midwest could cut it in this office. (I kid.) Honestly, you were fantastic.

Amanda Patten, Jenni Zellner, and the incredible team at Crown Archetype. We are forever grateful for your patience, generosity, and expertise. We are honored to be a part of your list.

The *A Letter to My Mom* team supports the outstanding work of *Baby2Baby* and *Every Mother Counts* and wishes to express gratitude for all of their support with this project.

Photo Credits

Melissa Andries (147, second from bottom)
Chris Baldwin (146, top)
Victor Bernard (154, bottom four)
Vivien Best (104, right)
Nathan Bolster (121)
Charles Bush (104 left, 152 second from top)
Erica Chan (120, top)
Stephanie Cristalli (14)
Dalal Photography (133)
Andrew Eccles (154, top)
Paige Elizabeth (148, bottom)
Jeremy Freeman, © 2014 Cable News Network.
 A Time Warner Company. All Rights Reserved. (150, top)
Fuzzie Beastie Photography (145, second from top)
Jennifer Graylock, courtesy of OWN: Oprah Winfrey Network
 (148, second from top)
© Heidi Gutman/American Broadcasting Companies, Inc. (157, top)
Sharon Hardy (56)
Olaf Heine (145, second from bottom)
Becky Hill Photography (37, right)
Korey Howell Photography (143, top)
Vicky Irvin (43, top)
Jim Keen (108, top)
Allen S. Kramer/Texas Children's Hospital (142, top)
Steven Lewers (59, 147 top)
Bernie Lewinsky (69-70)
David Livingston/Getty Images Entertainment/Getty Images (134)
Kassia Meador (155, top)
Darby Nicole (153, second from top)
Jordon Nuttall/The CW—© 2014 The CW Network, LLC.
 All Rights Reserved. (151, top)
Suze Orman Media, Inc. (91–92, 150 bottom)